LAKE SUPERIOR
NORTH SHORE EXPERIENCE

JAY STEINKE
PHOTOGRAPHER

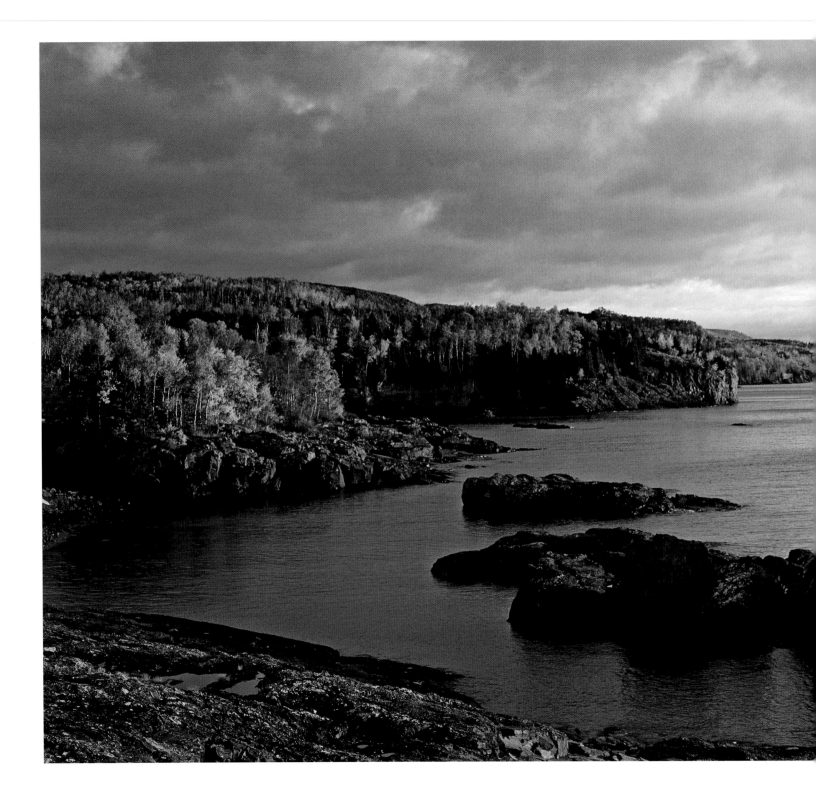

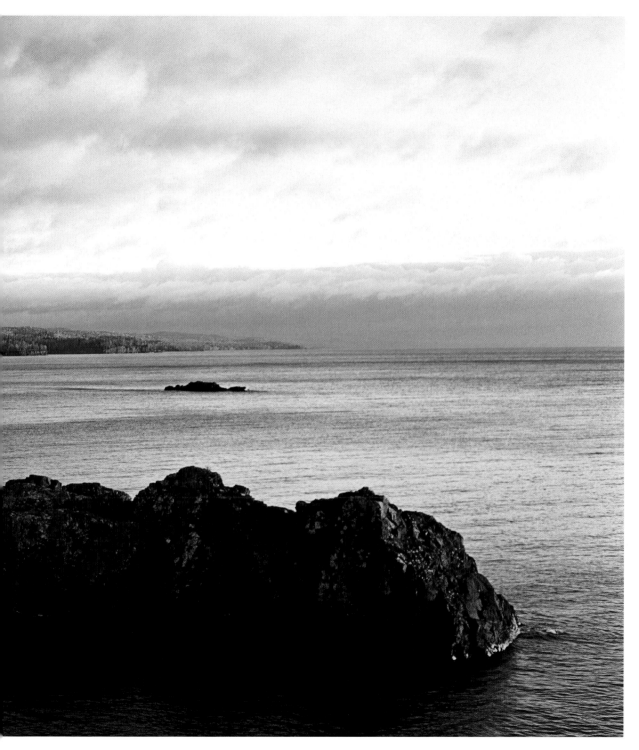

SHORELINE GRANDEUR

3

SHARING A VISION

Providence worked its way into my life at an early age. I first walked into a photography darkroom, housed in a small closet, at a Cub Scout meeting. I was nine years old.

My eyes grew in wonder and curiosity, as the eyes of a child do, as I discovered the trays, safelight and enlarger. My life's course and career were set in motion. As I developed a love for the natural world through my wanderings along Lake Michigan and the surrounding forests, I found my emotions responding to the beauty of nature. I was learning to feel its touch upon my heart. Photographs were made in my mind's eye, because I didn't possess a camera until many years later. I was learning to see . . . becoming a photographer and privileged to share my vision with others.

Decades later, I traverse the hills, lakes, rivers and shoreline along Lake Superior's North Shore with camera in hand. There are not many places I would rather be doing my life's work, and a lifetime is not enough to acquaint oneself with this magnificent area. If I have revisited a spot a dozen times, it is always different when I return. Perhaps a stately white pine has fallen, or new growth has risen to obscure a vista, or a river's edge may have been newly sculpted by the wear and tear of the forces of nature.

The fortunate people who make their home here or visit, experience this region in their own unique way. Some seek a wilderness experience, others a spiritual or romantic one, and still others are simply content to be living through the rhythms of the seasons. All are being challenged, inspired, or renewed by the magnificent displays of nature and the moods of the North Shore. Most can recall experiences, intimate to majestic, that they will carry through a lifetime. Through my photography I share a small portion of the delightful discoveries that can be experienced on the North Shore.

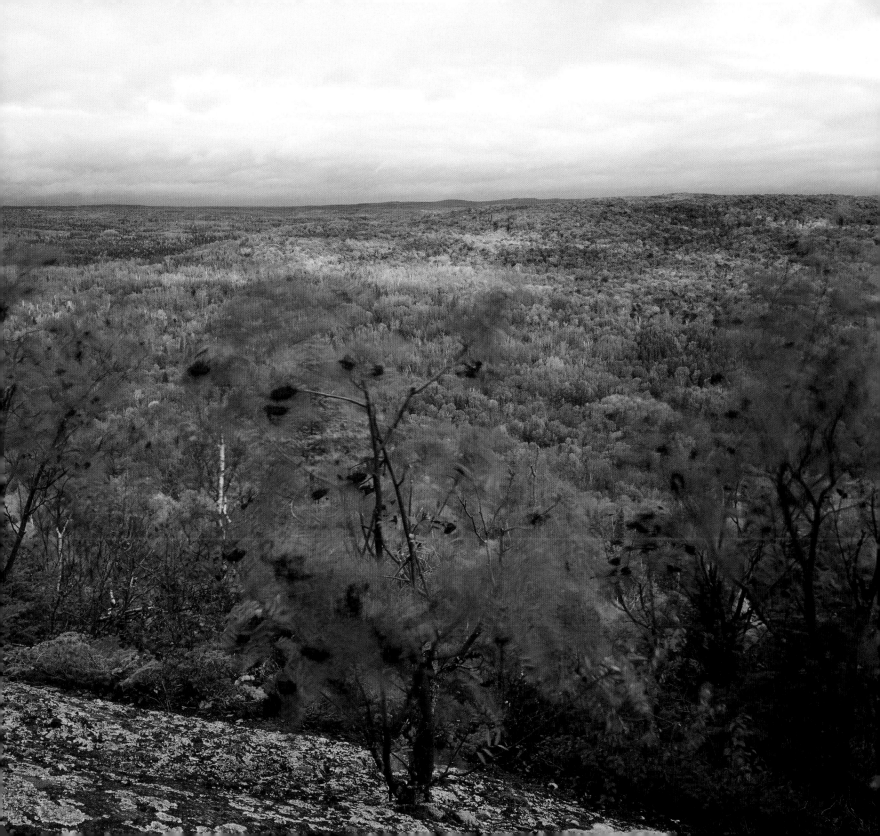

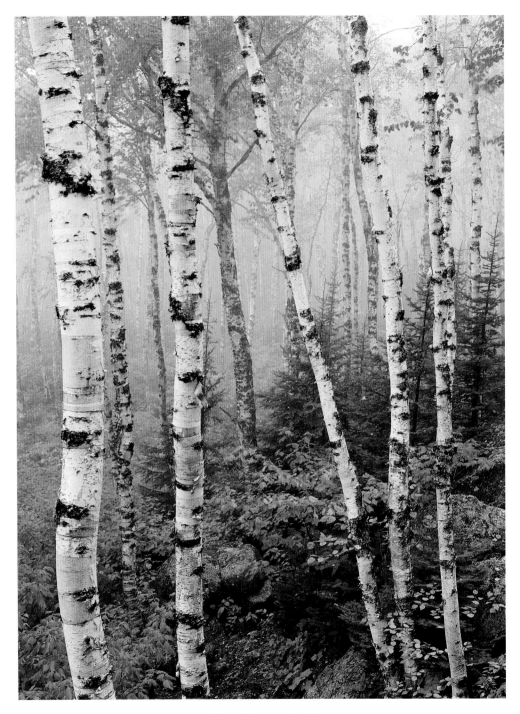

HUSHED FOREST

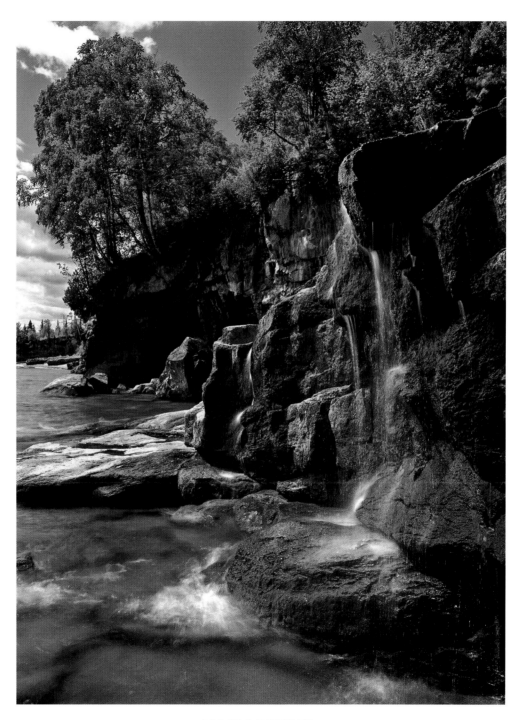

SPRING RIVULET

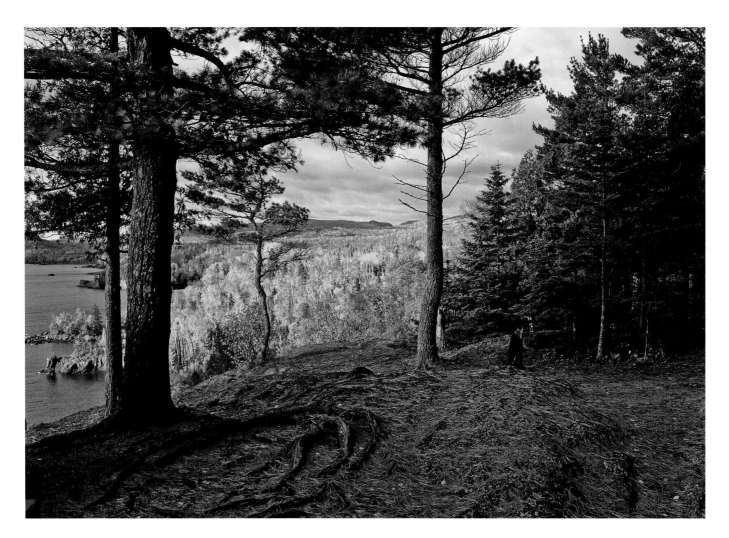

SUNSTRUCK HILLSIDE

The hunt was on. I've photographed from Shovel Point countless times, placing my tripod into the holes made by many others before me. This time I'd been out for a month, photographing every day until I had entered into calmed patience. I could take my time to truly see. My hunt was for a different perspective; I knew what I wanted the light to do. After scouting locations for a few hours, I found my spot, set up the camera and fine-tuned my composition an inch at a time. But, I didn't take my shot this day. Later, I returned at the precise time on the perfect day with patchy light. I waited for sunlight to strike the forest canopy while the foreground remained darkened. Yellows burst from the shadows and I got my prize. This was the finale, for in a few days the forest floor would become a sea of leaves.

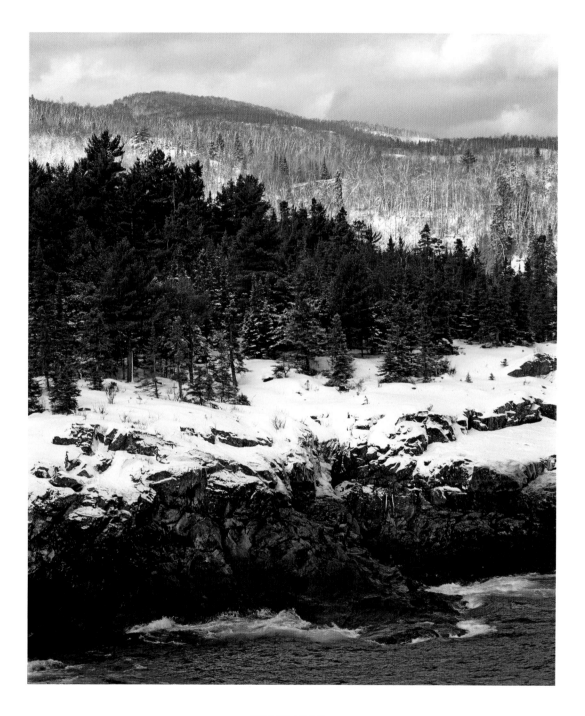

HIGHLANDS

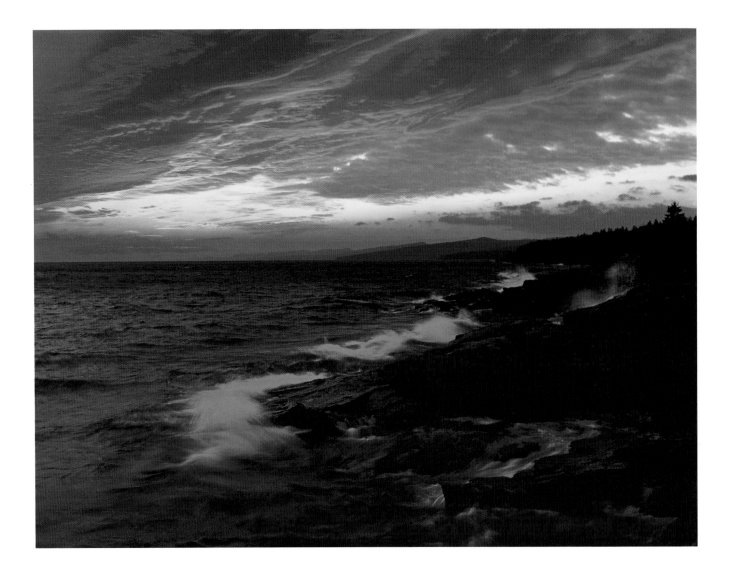

PAINTED SKY

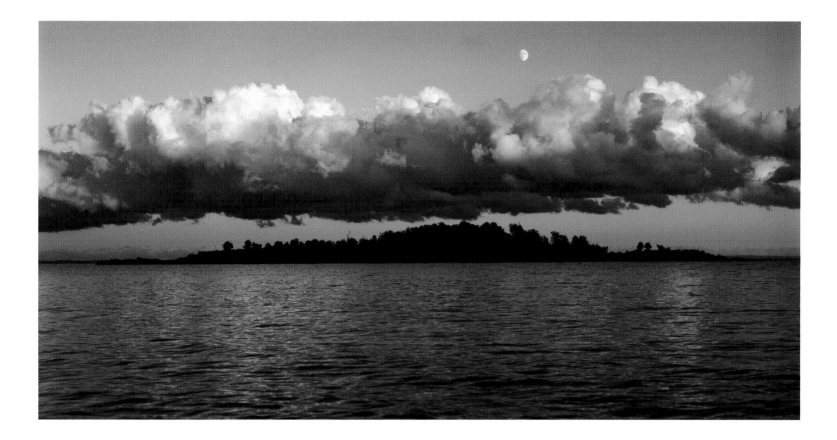

KNIFE ISLAND

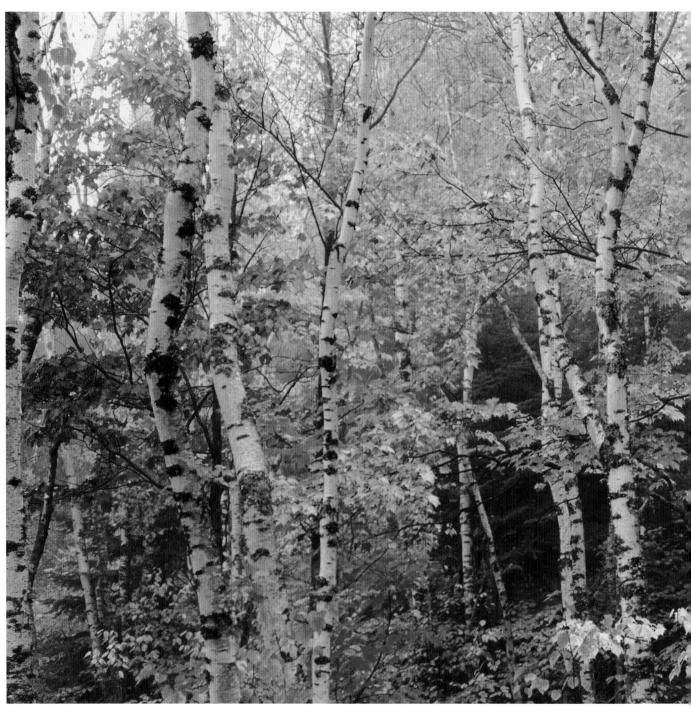

INTERWOVEN MAPLES

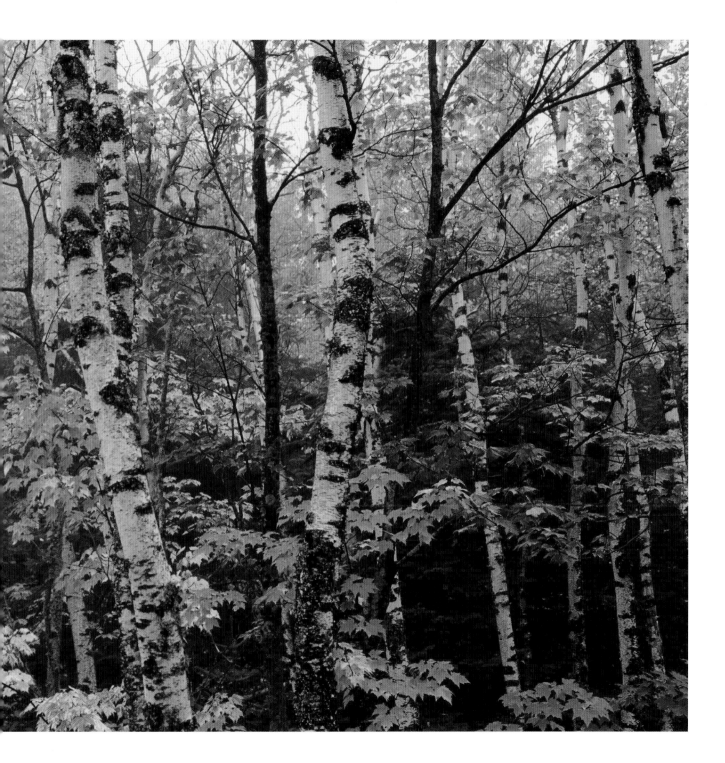

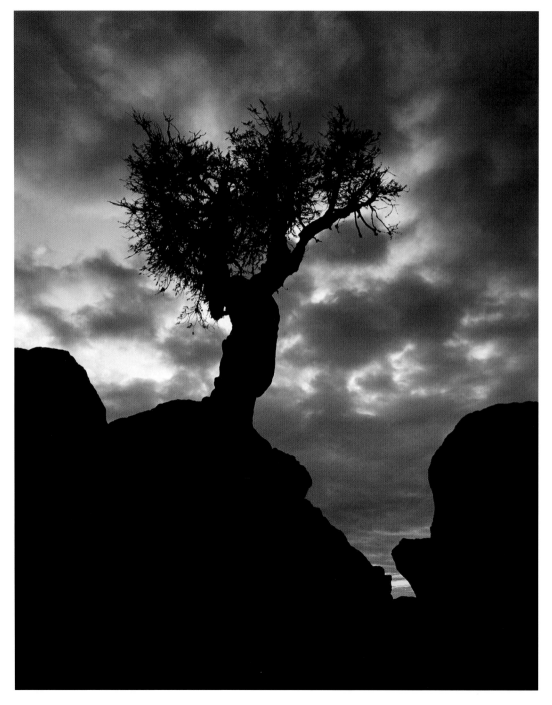

GNARLED WITCH TREE

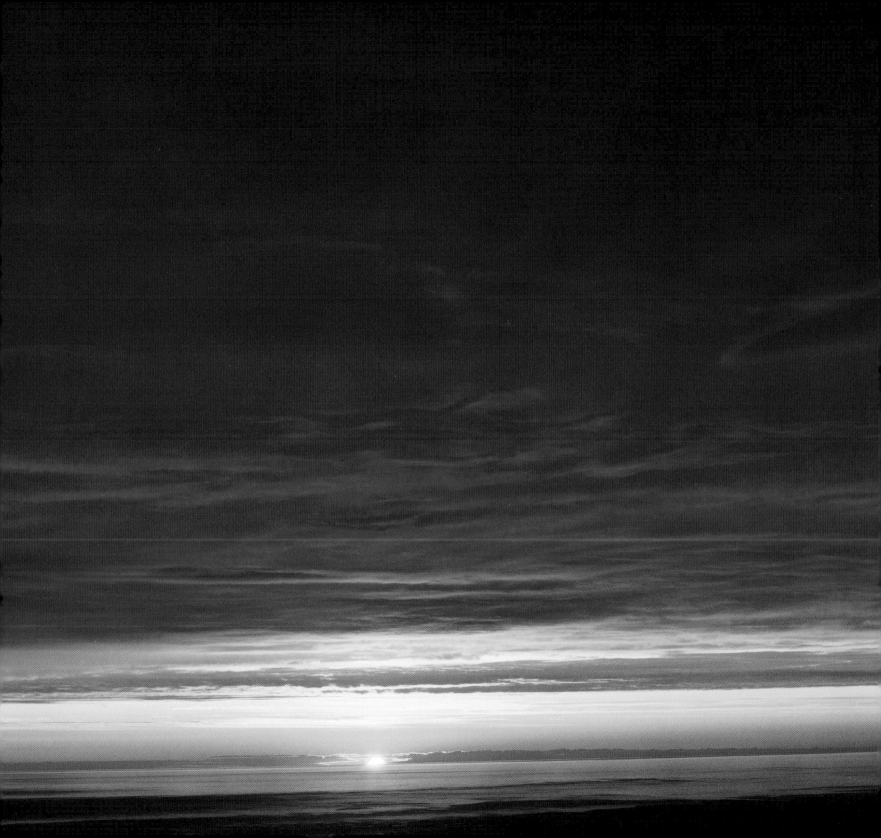

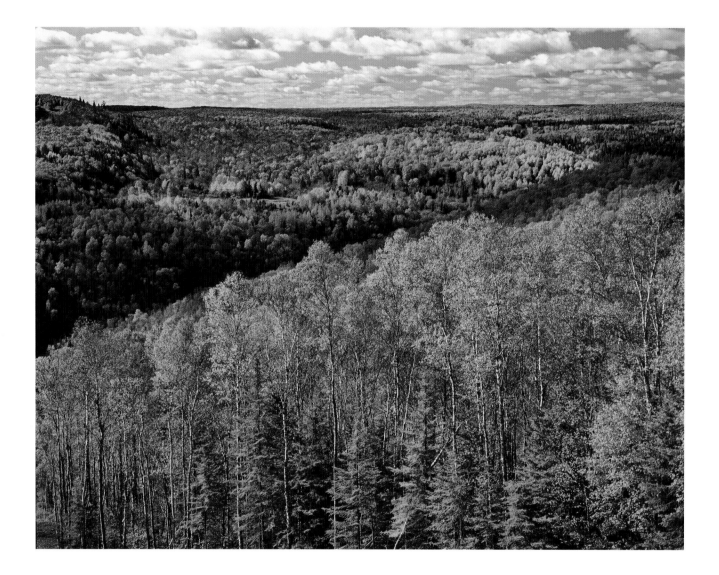

LUTSEN MOUNTAINS

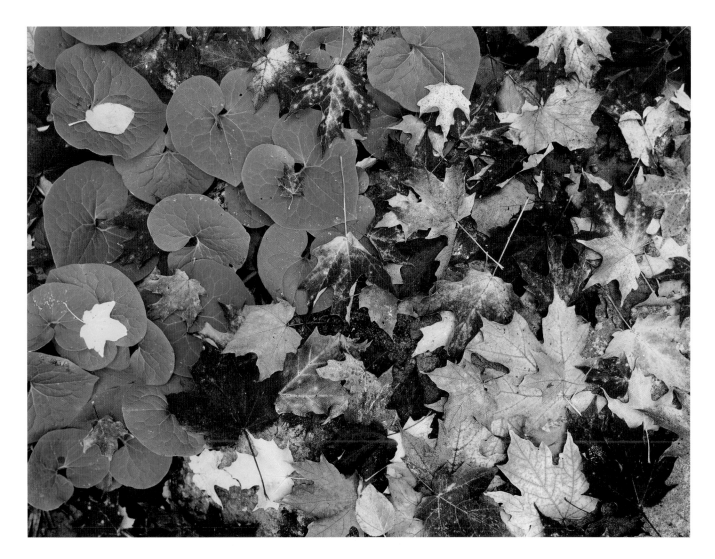

FOREST TAPESTRY

Rain showers, hail showers, snow showers…on this autumn day I was caught in a leaf shower. As the wind tore at the trees, I headed into the forest to find a little calm. So blustery outside, it remained quiet and still within. Each gust broke loose the glorious colors, quivering above, and leaves began silently raining down on me. Trying to coax a composition out of chaos is a challenge. "Looking" intensely, the eye must scan thousands of changing arrangements. Then, as a jewel in the rough, one shines out, as if laid there for a passing photographer. The juxtaposition of color and shape was nature's simple gift for me today.

17

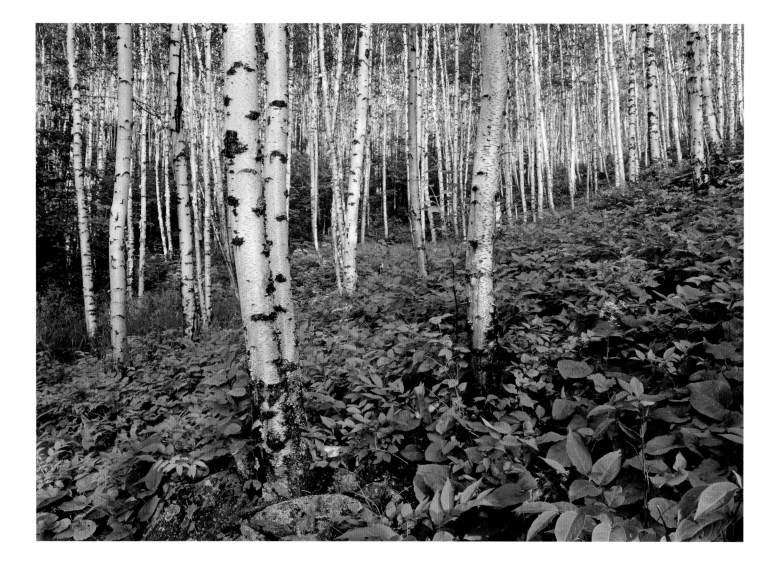

BIRCH GROVE

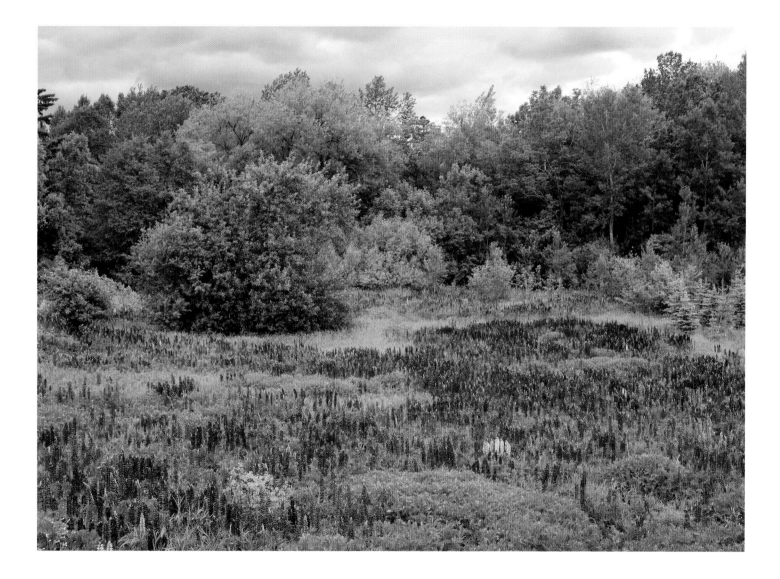

LUPINE VALE

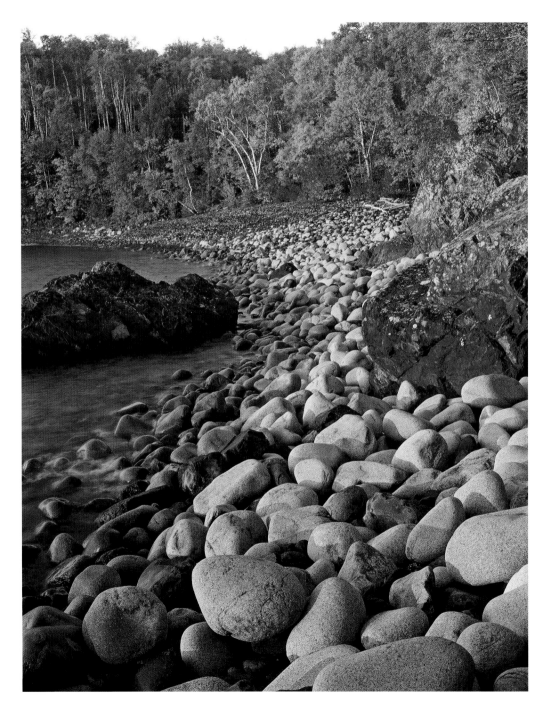

COBBLED COVE

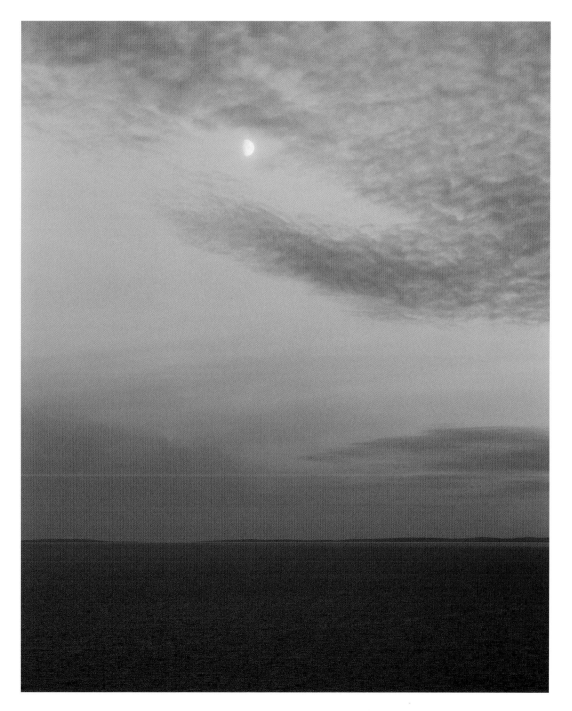

EVENING GLOW

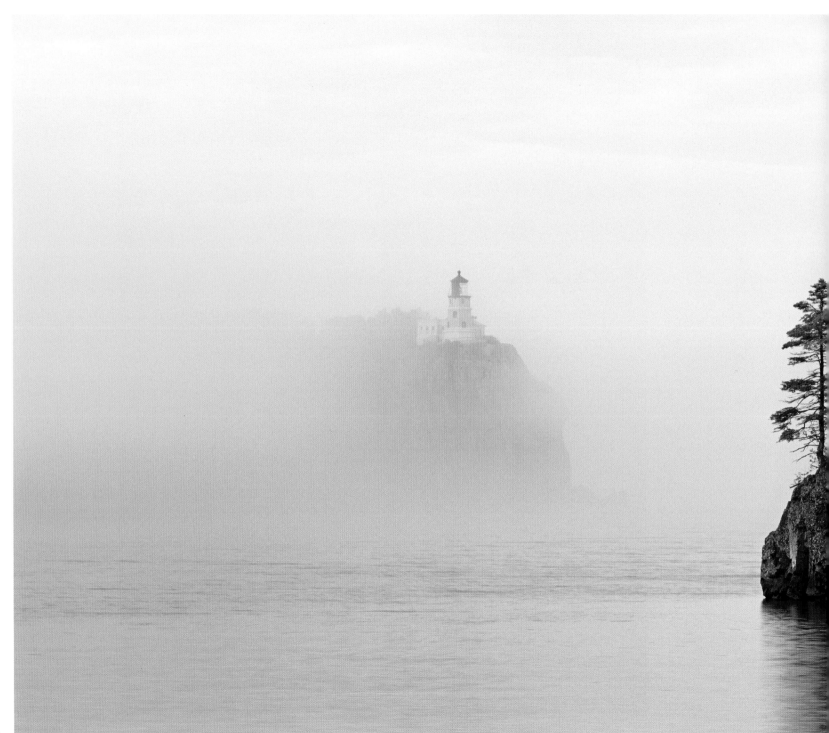

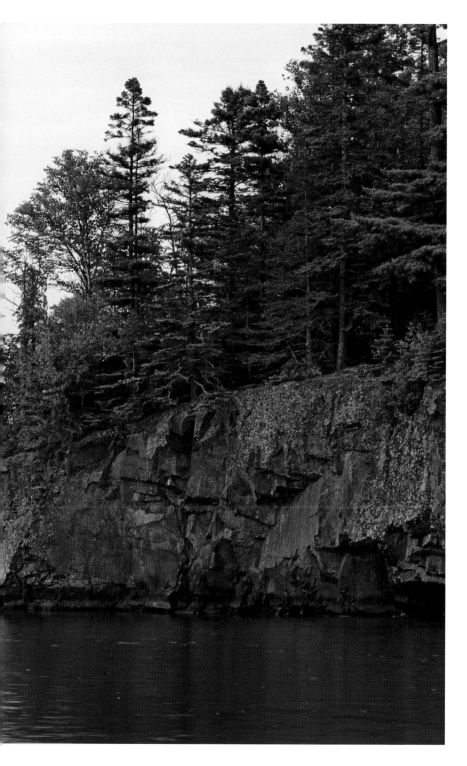

FOGGED IN

A hush emanates from the waters. The fog softly moves. It rises, falls, spins, and retreats as a dance takes place due to cold lake air engaging warm breezes from the land. This is a common playful game between lake and land in early summer on the North Shore. If you watch these two interact with each other you will find it a quiet and restful experience. Shrouded in fog, this sentinel of the lake, Split Rock Lighthouse, stands retired from its heroic duty of guiding ships and saving lives. Now, it proudly poses for photographers and painters. I am among the tens of thousands joining in the ritual, clicking my shutter.

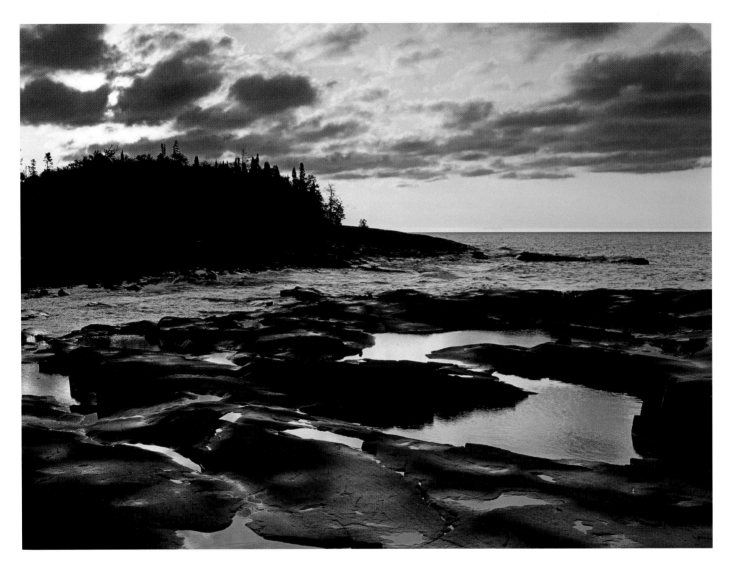

ARTIST'S POINT

God knows all about Artist's Point. Certain natural places on earth have the ability to draw out the human heart, places where communing with Him gets real. Countless people make the pilgrimage to Artist's Point. Here, they discover love, make vows, and resolve great matters of the heart, and parents introduce their children to Lake Superior. Here, tears of joy and sorrow fall to the rocks and good-byes are cried to loved ones lost. Yes, God knows all about this beautiful place. I've come to know it, too, and I've lifted my voice to the heavens here many times. This stretch of the North Shore remains one of my favorite, and the photographs that I've made from Artist's Point seem to have a majestic quality. Always, I am drawn to return.

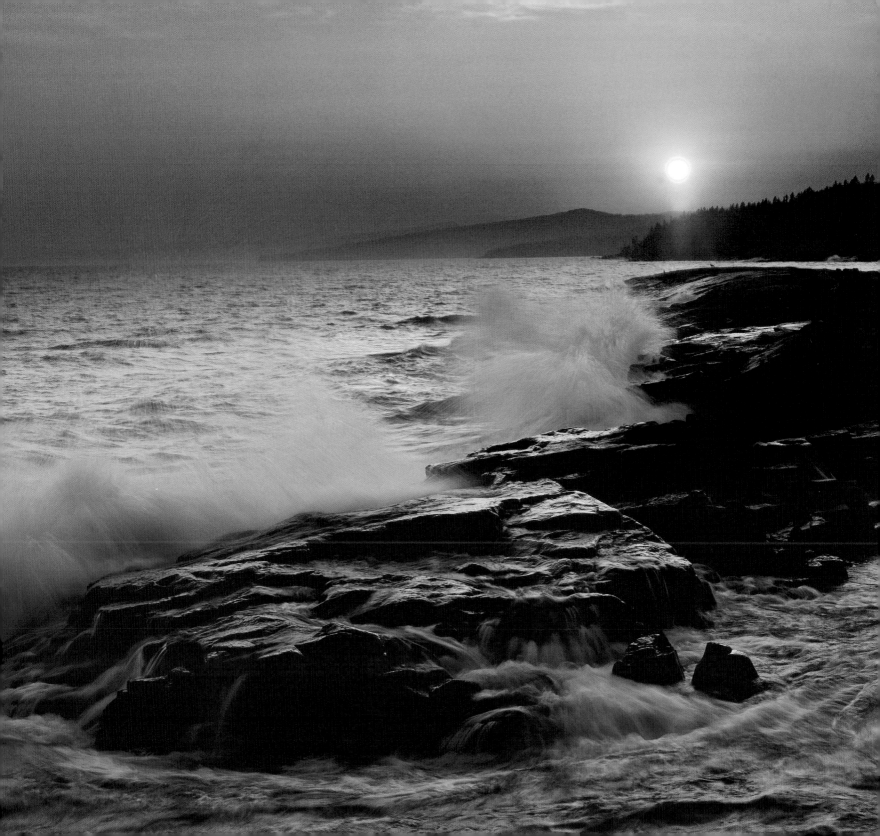

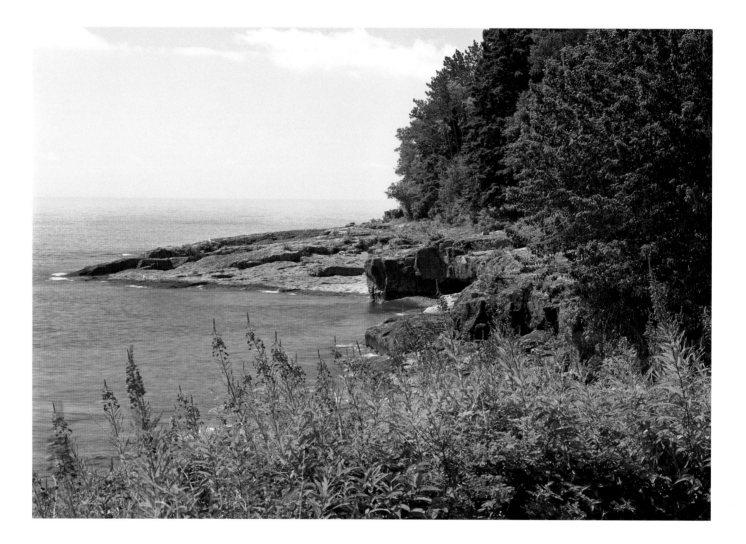

SUMMER FIREWEED

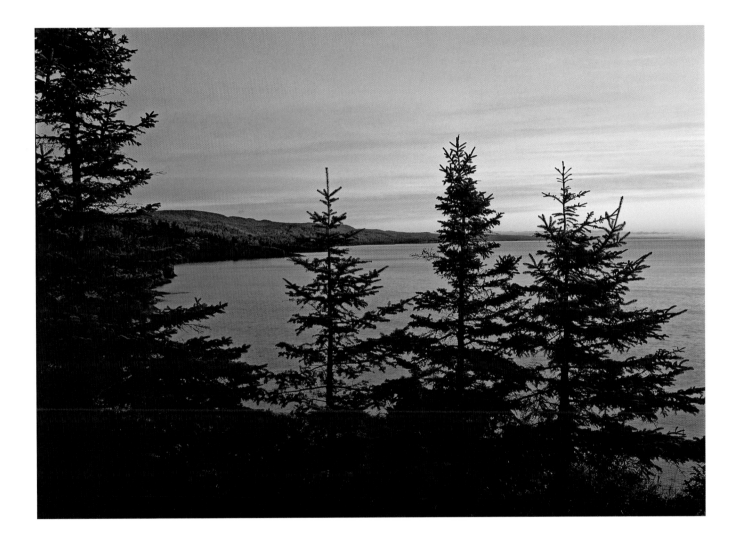

DAWN SPECTATORS

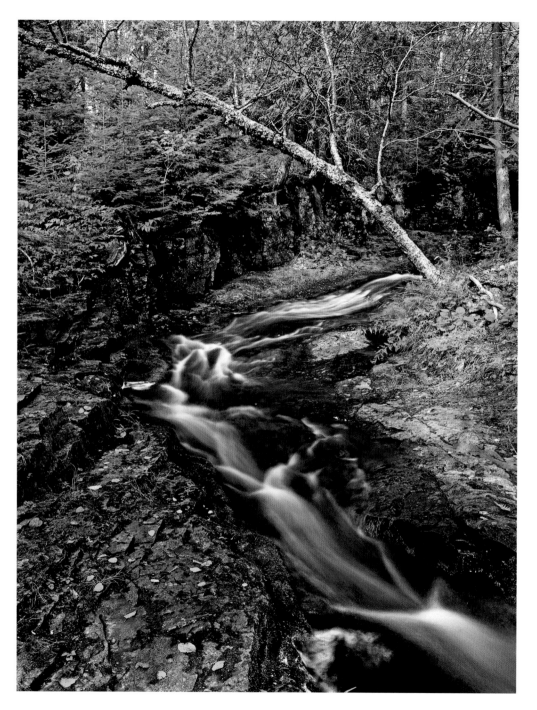

KADUNCE RIVER

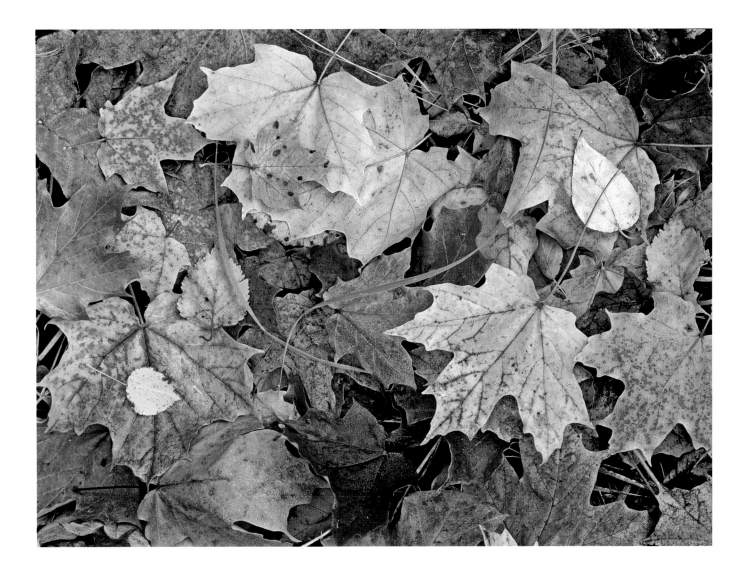

AUTUMN PALETTE

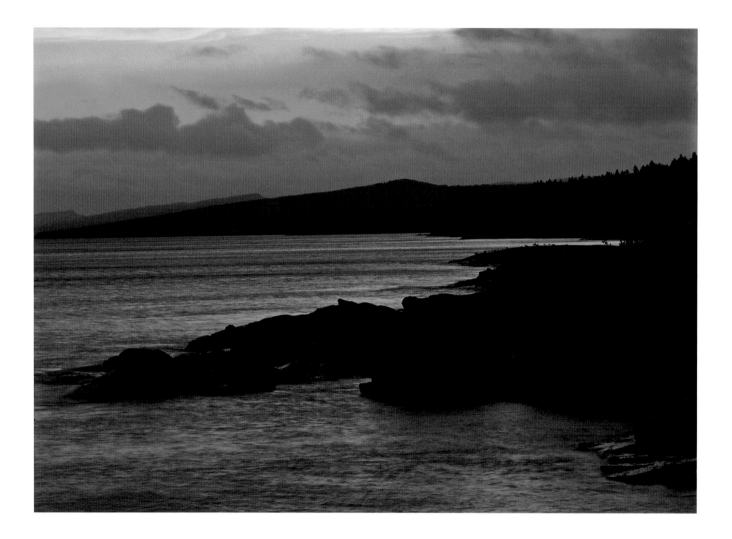

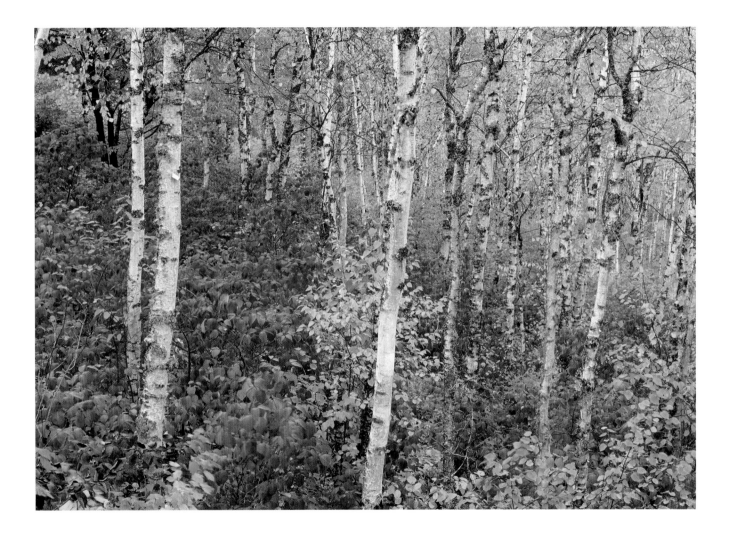

SAWTOOTH COLOR

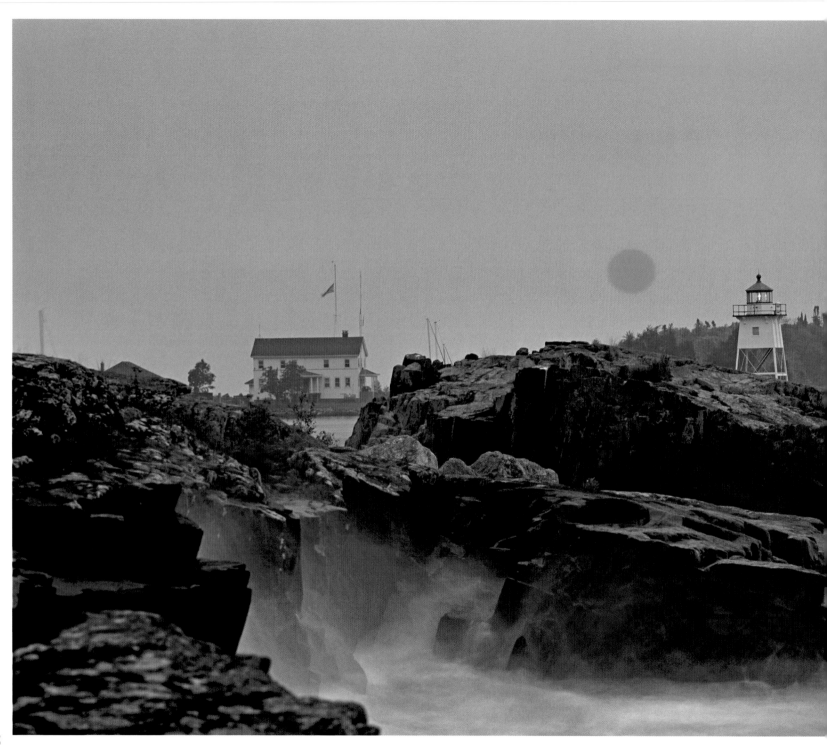

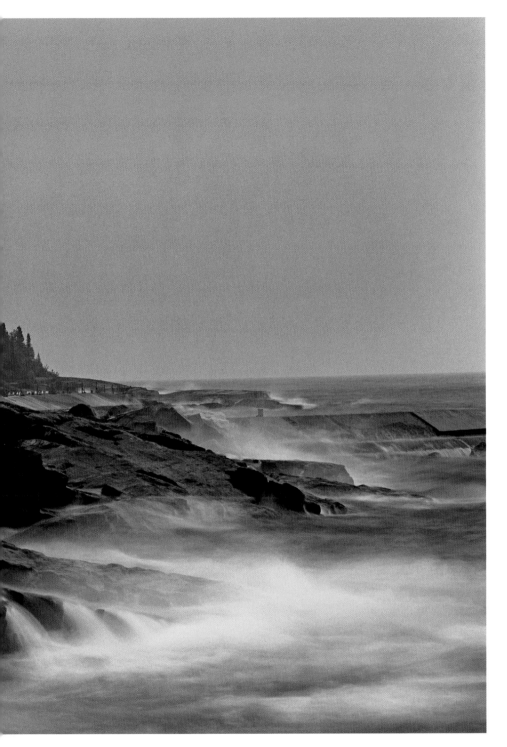

HARBOR LIGHT

My heart is very involved in making a photograph.
I try to capture emotions from a scene and put them
on film. This is the personal facet of image making.
Everything at the moment is keenly focused on this and it
is the pinnacle of the experience, and why I do what I do.
Anything that interrupts or changes this moment is agony
to the soul. The act of creating has been halted and the
communication has ceased. There might be too much
wind or too much sun or not enough, possibly it starts to
rain. I have experienced the frustration of missing a shot
by arriving minutes too late at a scene or waiting hours
while the right conditions never develop. Perhaps a person
wanders into my field of view and decides they want to
spend time right here in this spot! The agony and the
ecstasy! There is also the ecstasy of success, everything
coming together, the joy of capturing and communicating
what I saw and felt. This was a warm morning in Grand
Marais and I was out at sunrise. The waves were still large
from an evening storm and I was shooting down shore,
waves crashing on the ledge rock when they began to take
on a warm glow. Upon turning, I saw this dramatic scene
developing and swiveled my camera around, upshore.
Here I was, witnessing the gift of a new day, the sounds of
crashing waves below my feet, and the smells of a warm
summer morning on the North Shore. I departed from
there feeling the joy of making a beautiful image and
loving what I do.

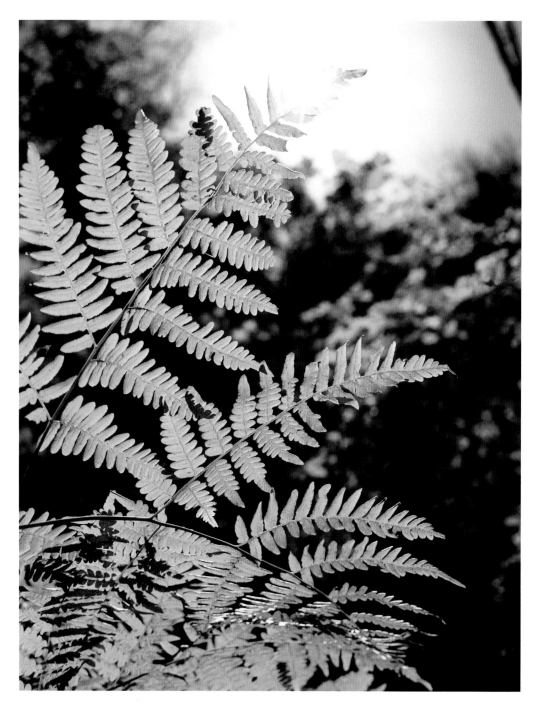

LUMINESCENT FERN LONE SPRUCE

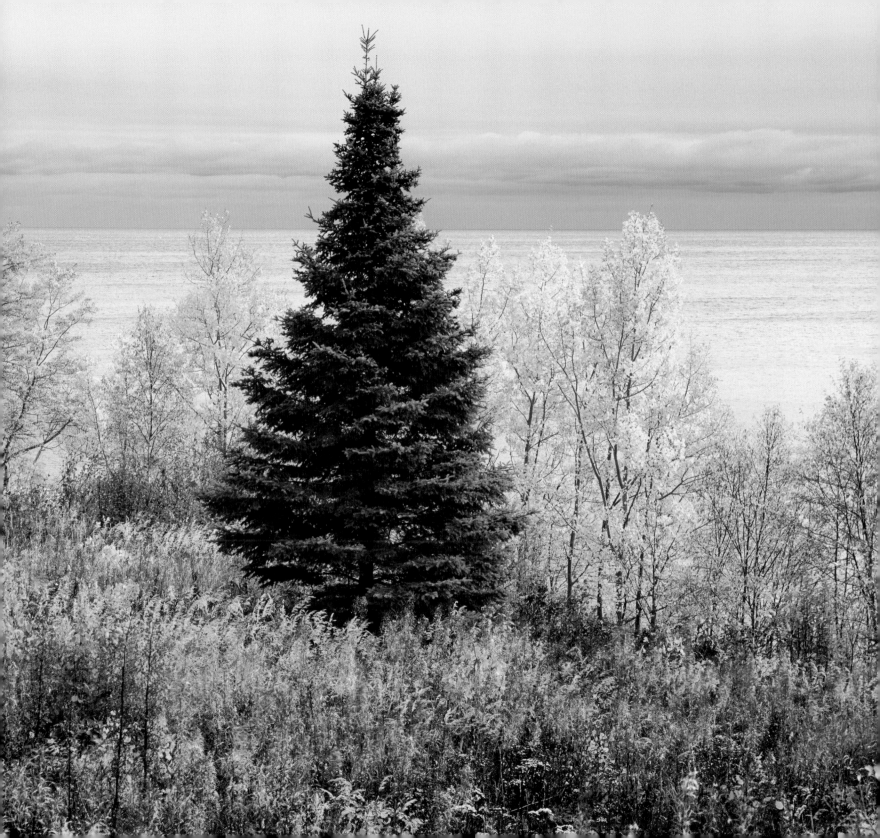

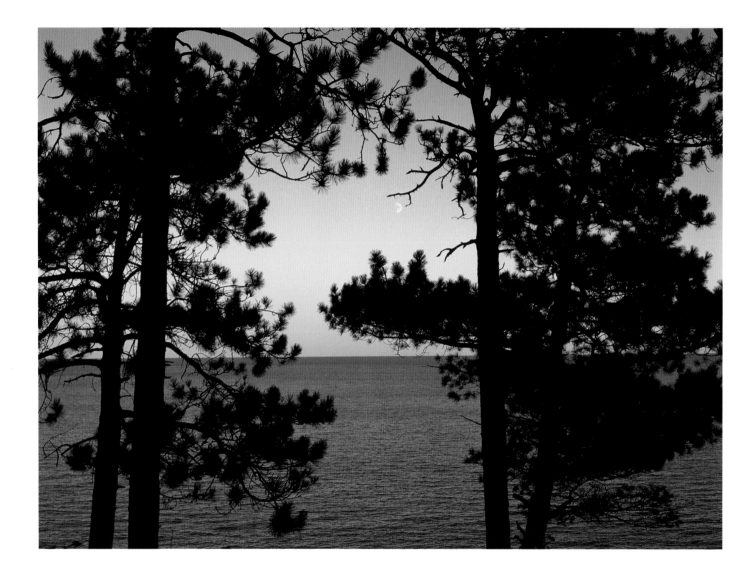

CRYSTAL POINT

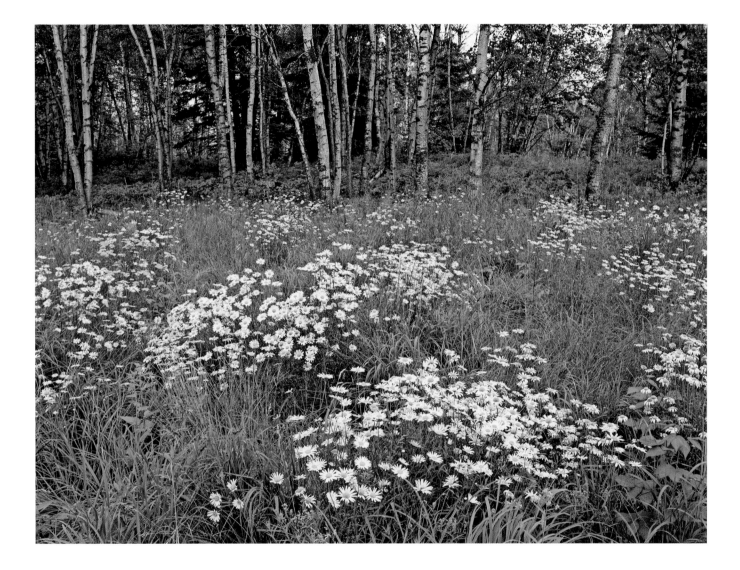

MOON DAISIES

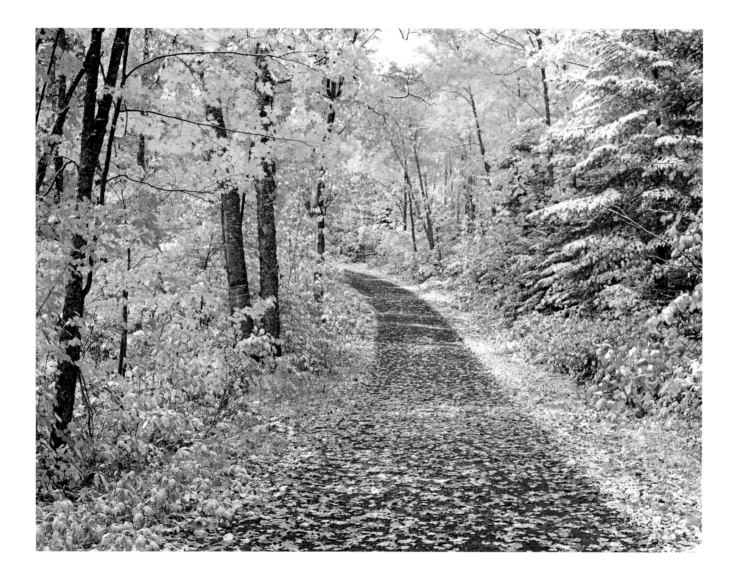

PROMISE OF WINTER

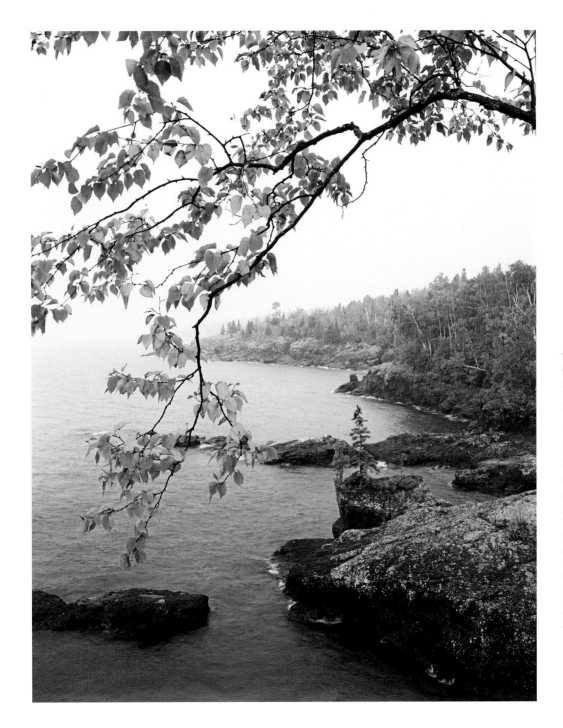

TOUCH OF FALL

Almost oriental in design, the simplicity of this scene attracted me with the interplay between the graceful and rugged. So very North Shore, the softened light wrapping itself around the leaves and rock. Honing my ability to "see" is my greatest challenge as a photographer. Our world is full of compositions waiting to be discovered. Wonderful colors, designs, shapes and light displayed in nature are hidden from an untrained eye. The sensitive heart and eye must form a union. I can see, but it is only with the heart that an image is made which communicates life, emotion, and beauty. Therein lies the challenge.

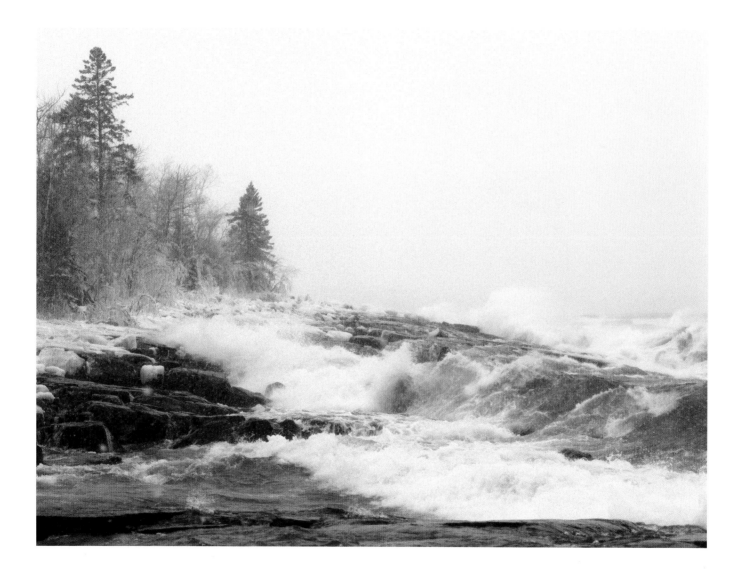

STONEY POINT

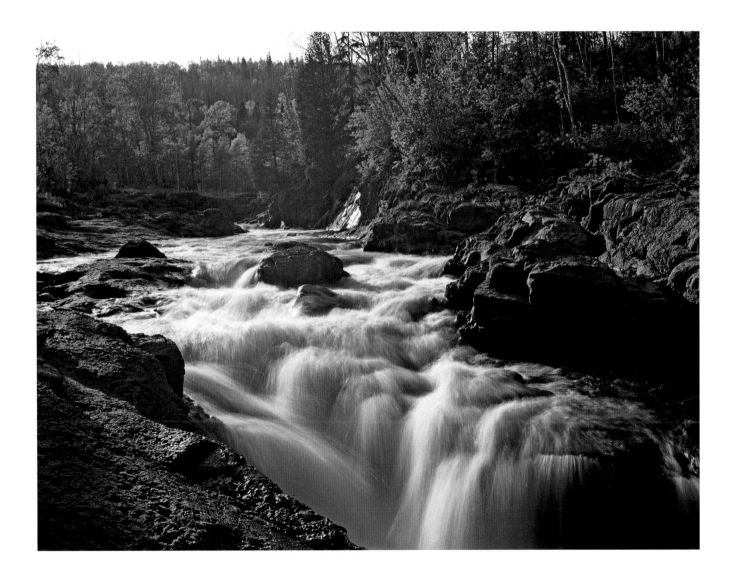

CASCADING TEMPERANCE

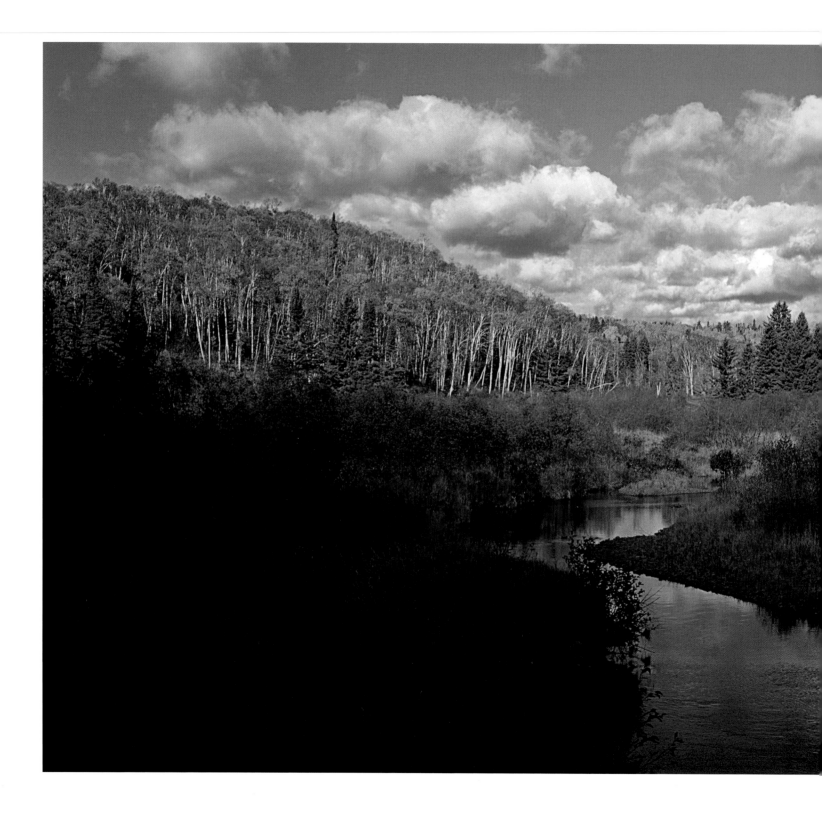

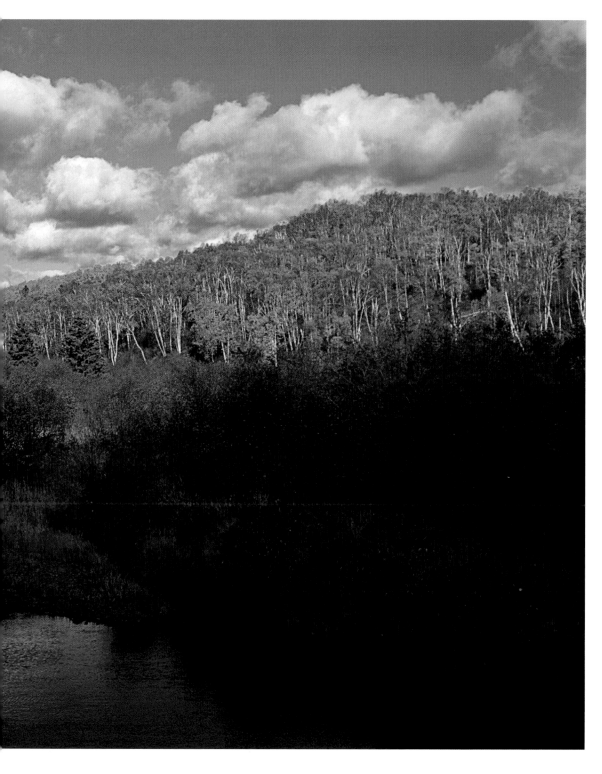

SPLIT ROCK RIVER VALLEY

43

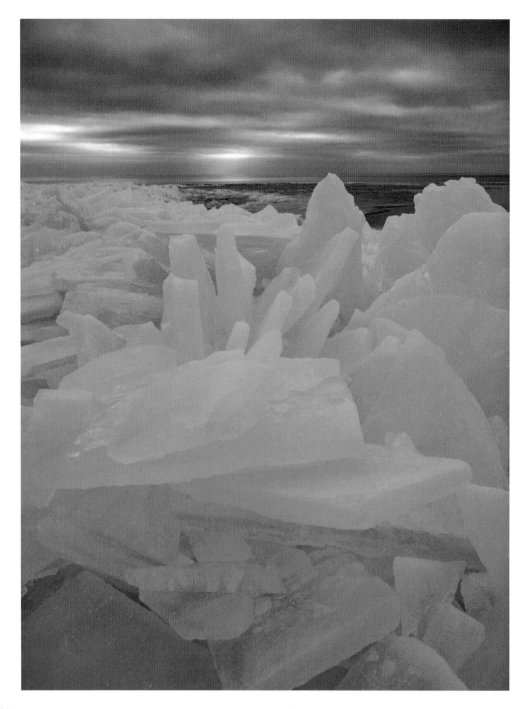

45 NOR'EASTER

The power of the lake overtook me.
I could hear it as I approached.
Thundering shores and wind combined
with my accelerated breathing, as
I anticipated what I would see.
Few experiences rival the exhilaration of
witnessing a nor'easter on the
North Shore. When I arrived at this
location, there were two inches of wet
ice sloping toward the lake. This would
be dangerous. Physically and mentally
I shifted into high alert. Clinging to
small branches, I worked my way
toward the icy edge, aware of the risks.
At times I must push it to capture
a dramatic shot. Photographers
understand this. Fighting the incredible
wind, soaked with spray, my camera
drenched, I concentrated on my footing
and catching the image. My emotions
ran high; Superior's emotions ran even
higher. Suddenly, the mother of all
breakers crashed in. I stiffened myself
against the wind and made my
exposure, shouting in excitement at
being so close to such great power.

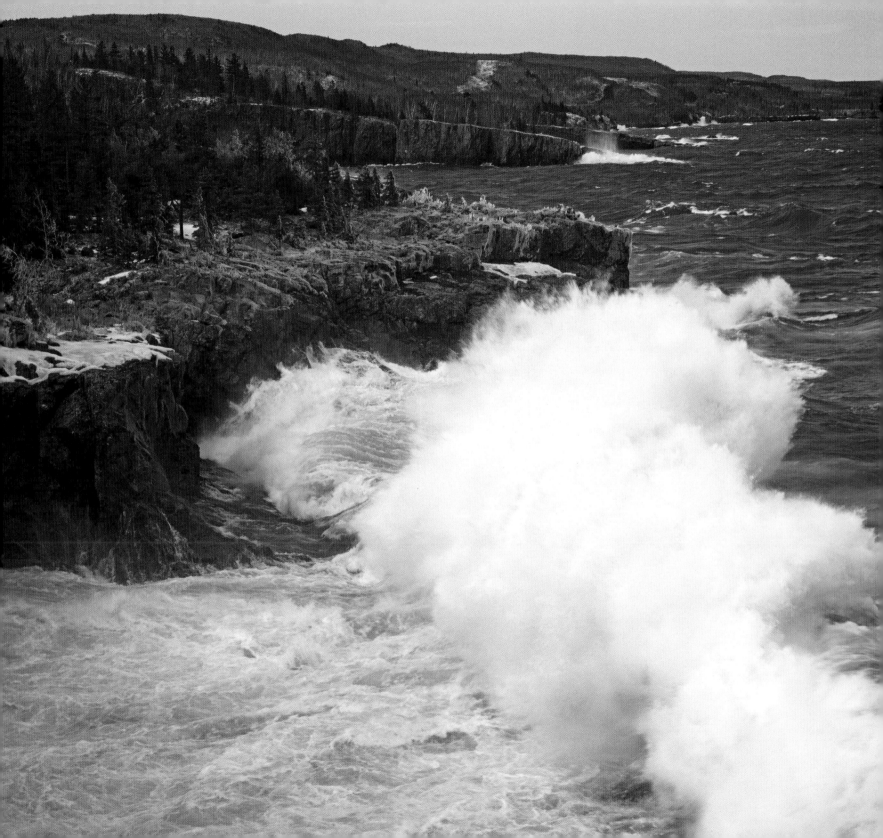

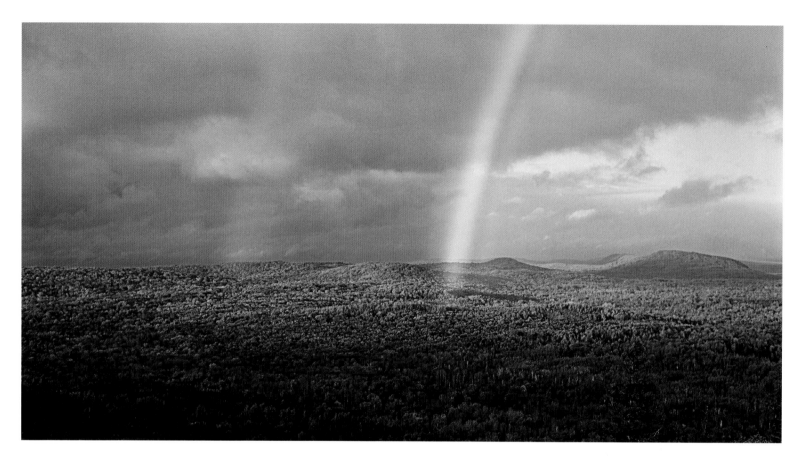

RAIN SQUALL

You simply can't "feel" the weather by looking at a photograph. You're not bracing yourself against 40 mile-per-hour gusts, the rain stinging your face and the cold numbing your fingers, making it difficult to operate the camera. I came to Carlton Peak in anticipation of what I could see brewing. The conditions were right with the sky breaking, rain, and the setting sun at my back. A small pine shielded me from the wind as I waited for the sun to break free from the clouds. A law of physics was fulfilled and a rainbow appeared. Then everything moved fast. Clouds, light, photographer...suddenly it was over. I lingered for a while to savor what I had just witnessed, reliving the moment, as the wind and rain pummeled me.

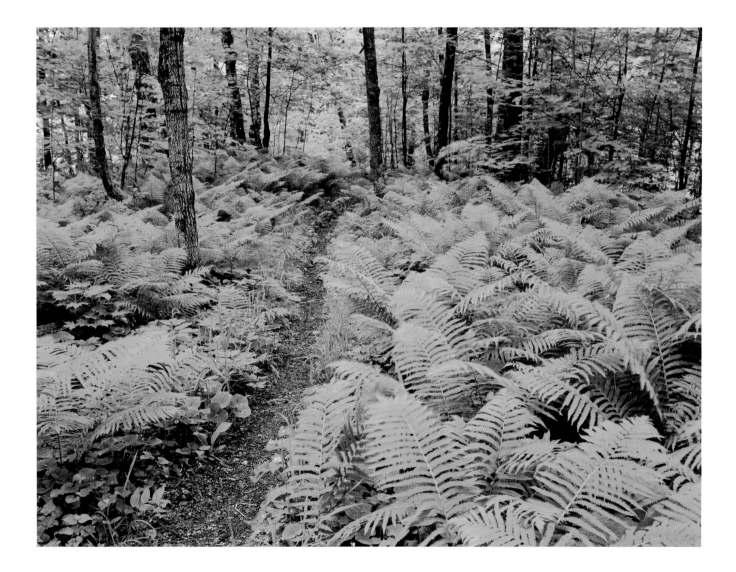

QUIET PATH

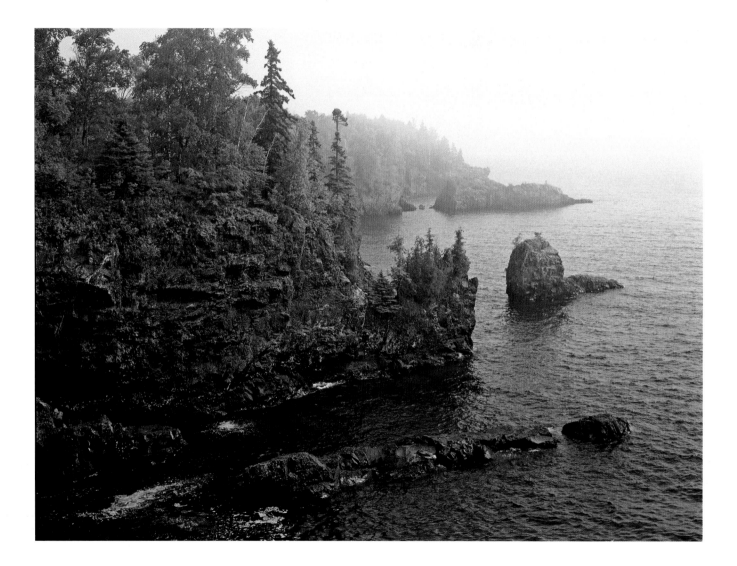

SCULPTURED SHORE

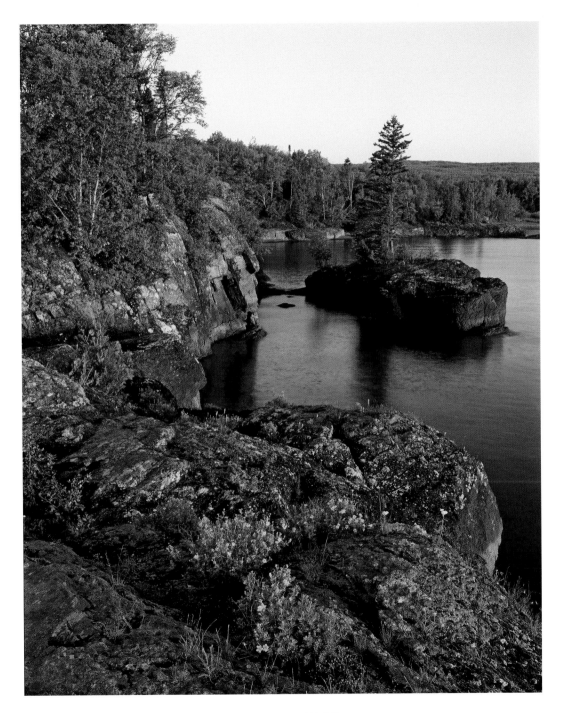

GRAND PORTAGE

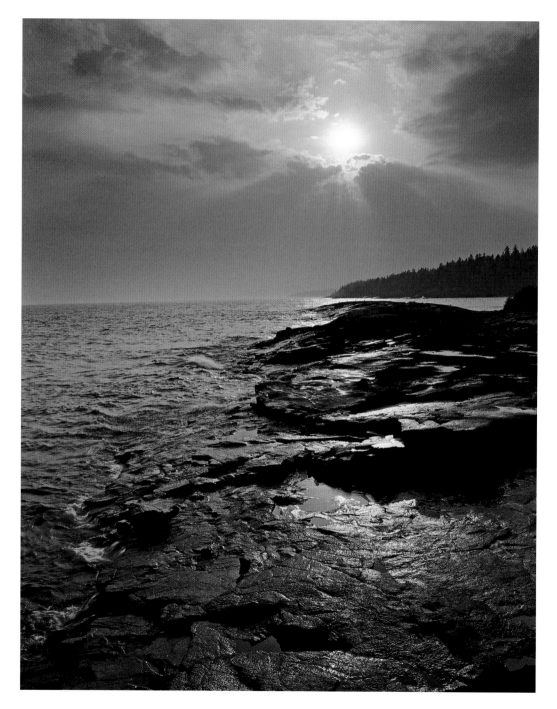

REFLECTING POINT

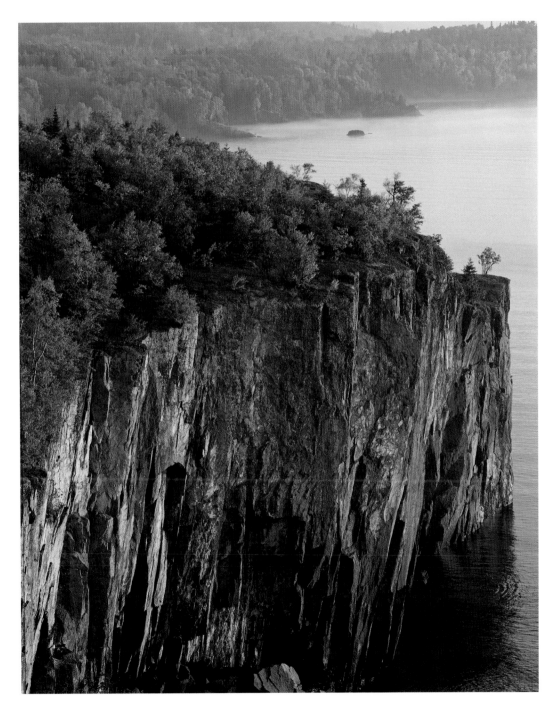

PALISADE HEAD

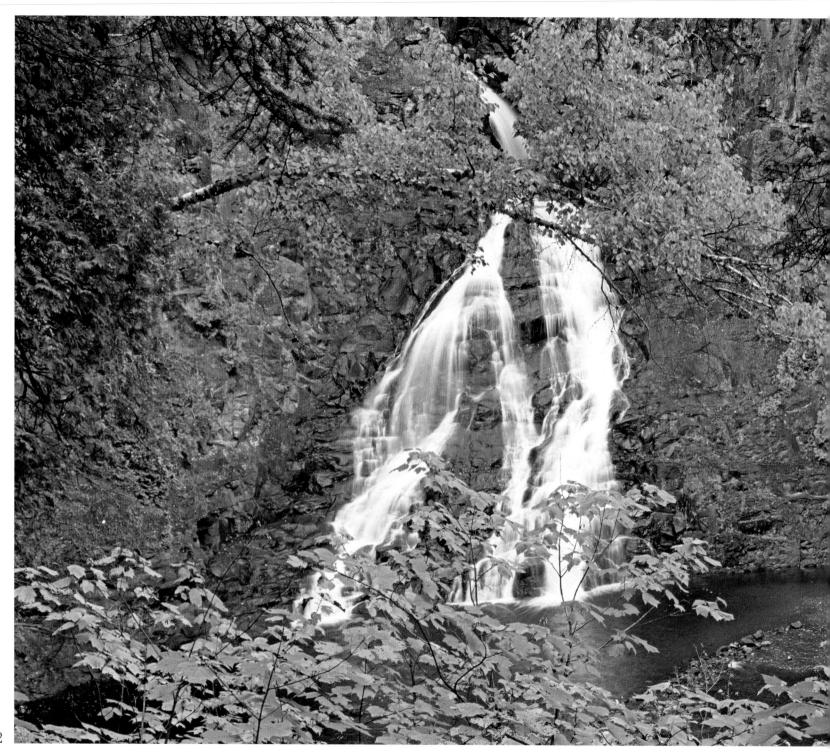

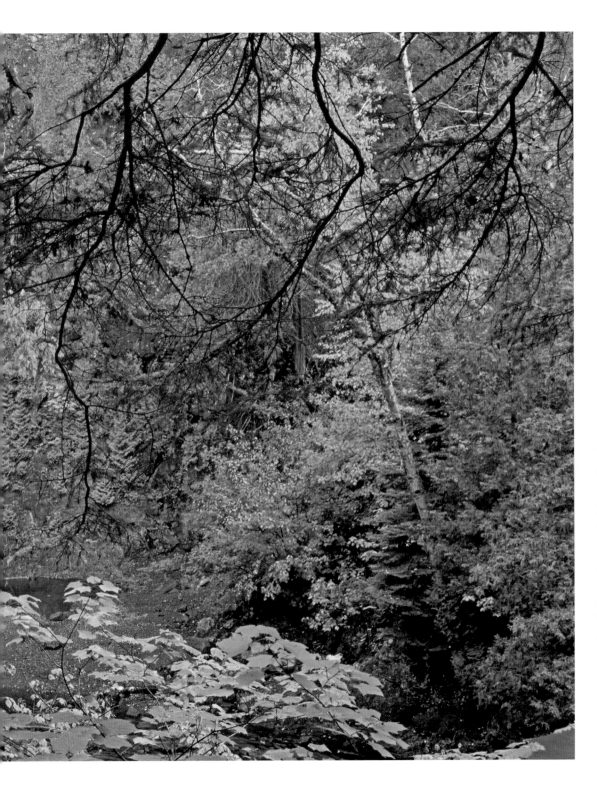

CARIBOU RIVER

This was the perfect amphitheater—with its rising canyon walls and sky above, the Caribou River was creating music. I found my rock, laid back, and closed my eyes. Time was of no essence. The music, gentle and soothing, massaged its way deep into the knots of my soul and body. I thought of David in the Twenty-third Psalm, led to quiet waters to restore and refresh his soul. Tranquil waters have this ability. When photographing rivers and streams, I always try to sit and let the melody of the water wash over me.

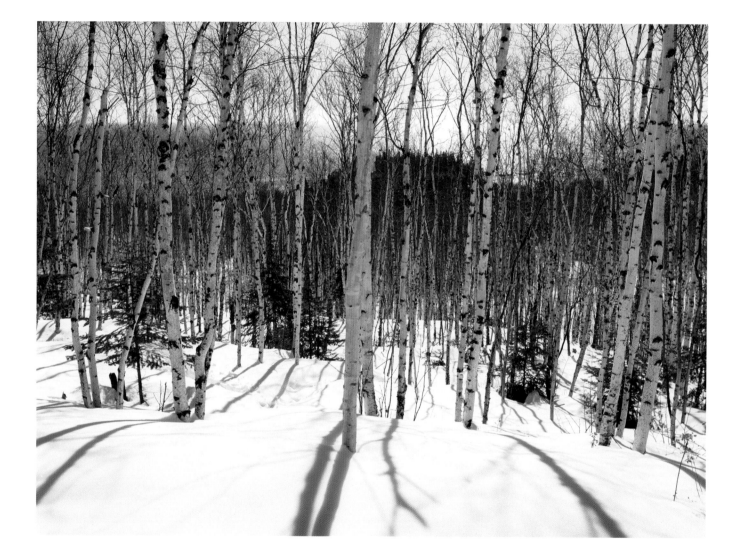

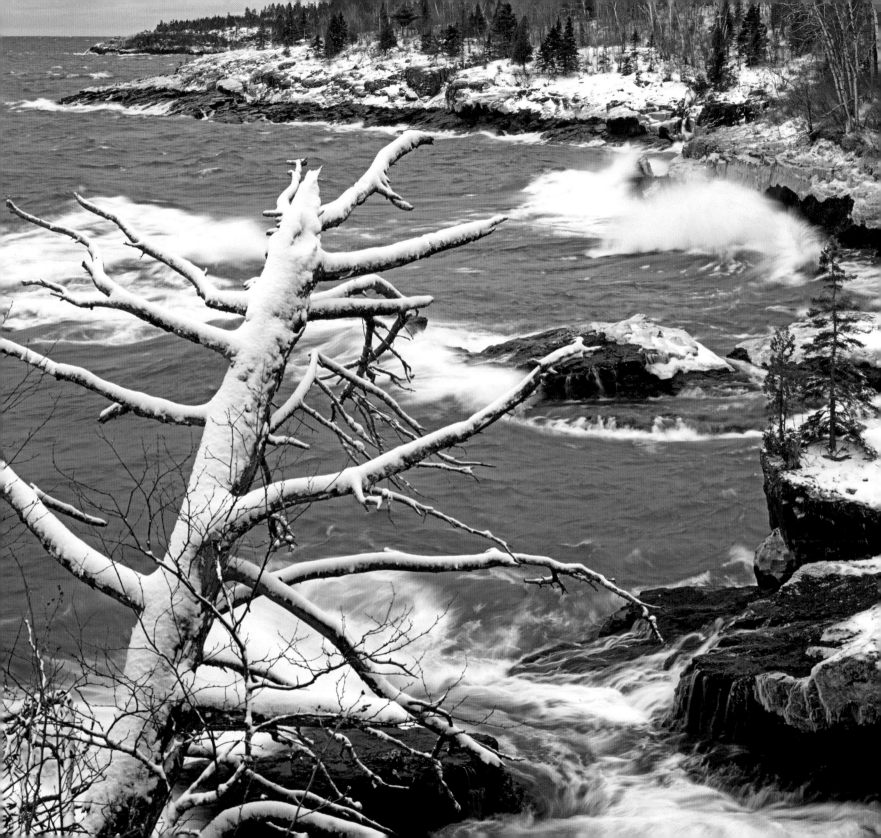

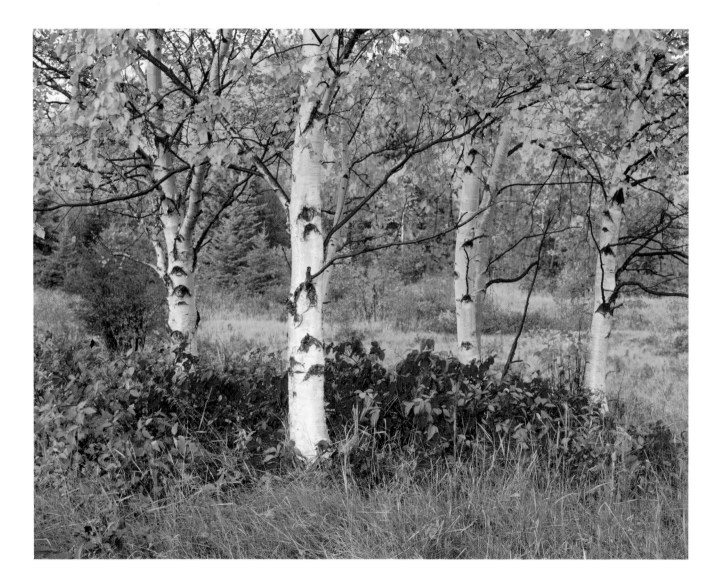

FOUR BIRCH

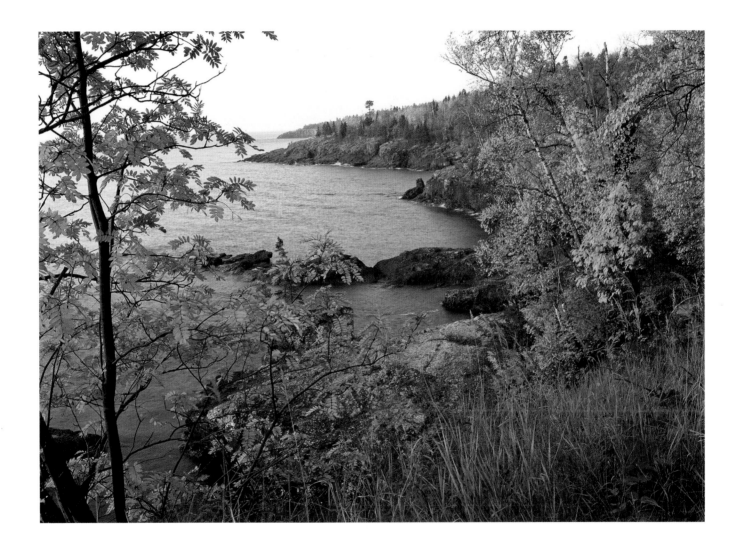

GOLD COAST

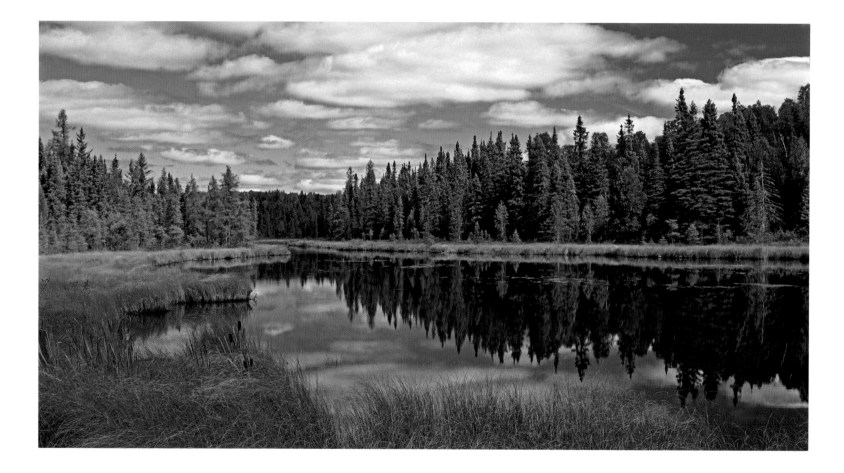

BLESSNER CREEK

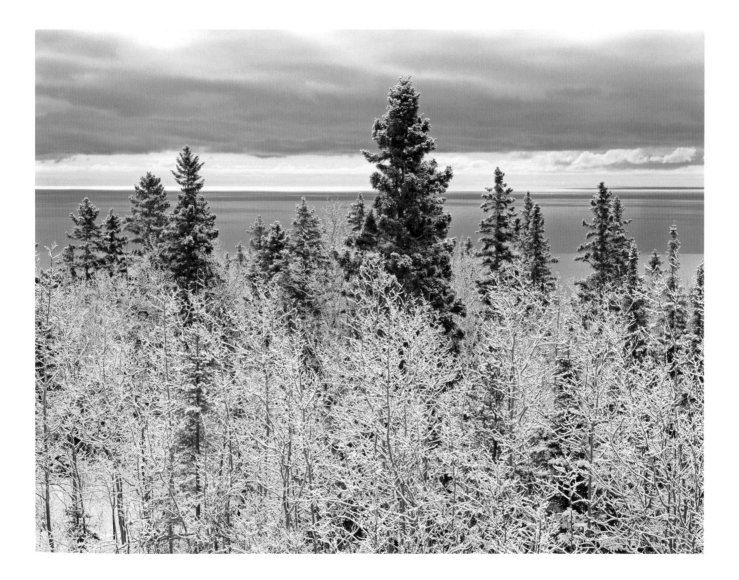

FROSTY VISTA

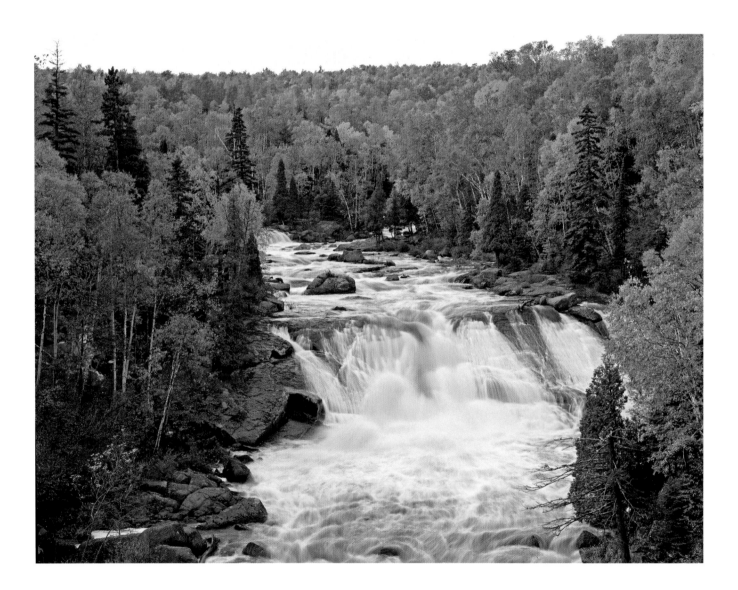

BEAVER RIVER FALLS

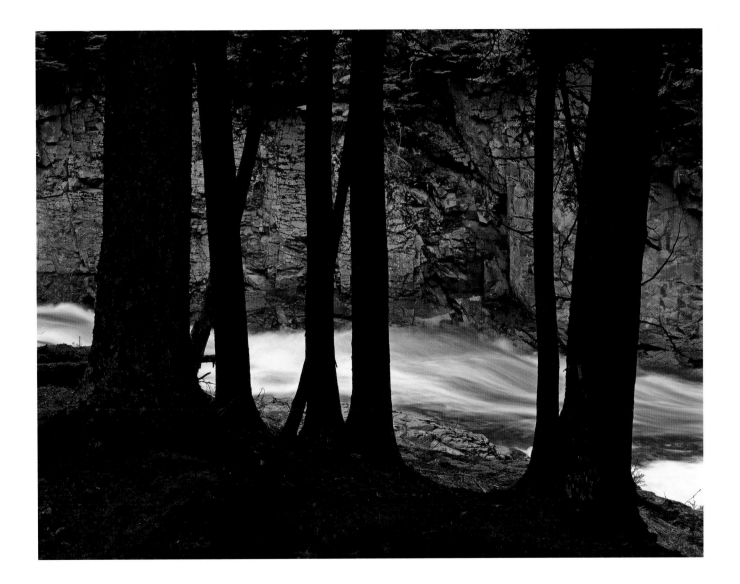

SPLIT ROCK RIVER

FOREST JEWELS

Fog lazily drifts through the sanctuary of
trees as I meander, alone, the trails of the
North Shore. This could be considered
gloomy weather and I am in it often
because of the soft light it offers. Happening
upon bunchberries can make anyone's day.
They bring a smile to my face as they beam
their joy upward. The forests are a cheerful
place to be in spring with the romancing
songbirds, the new birth of wild flowers, and
the perfumed air of the damp fertile earth
coming back to life. I walk slowly and softly,
as my senses imbibe what they were denied
through the long winter.

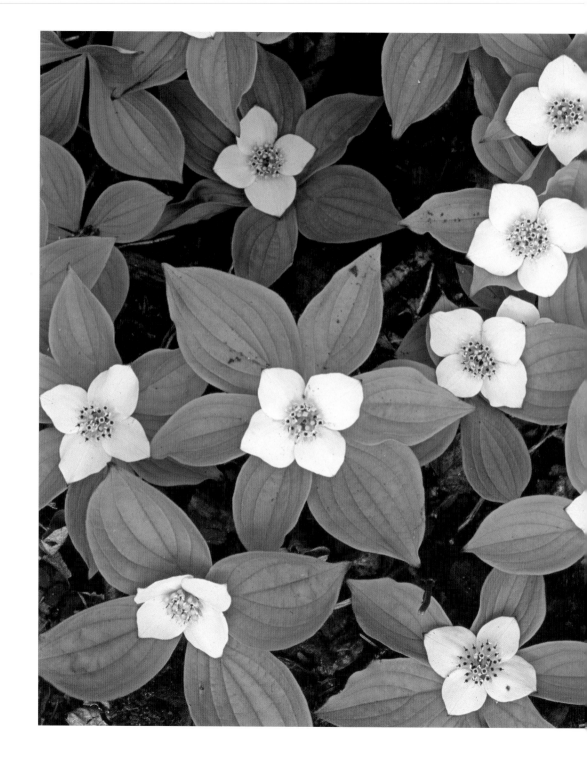

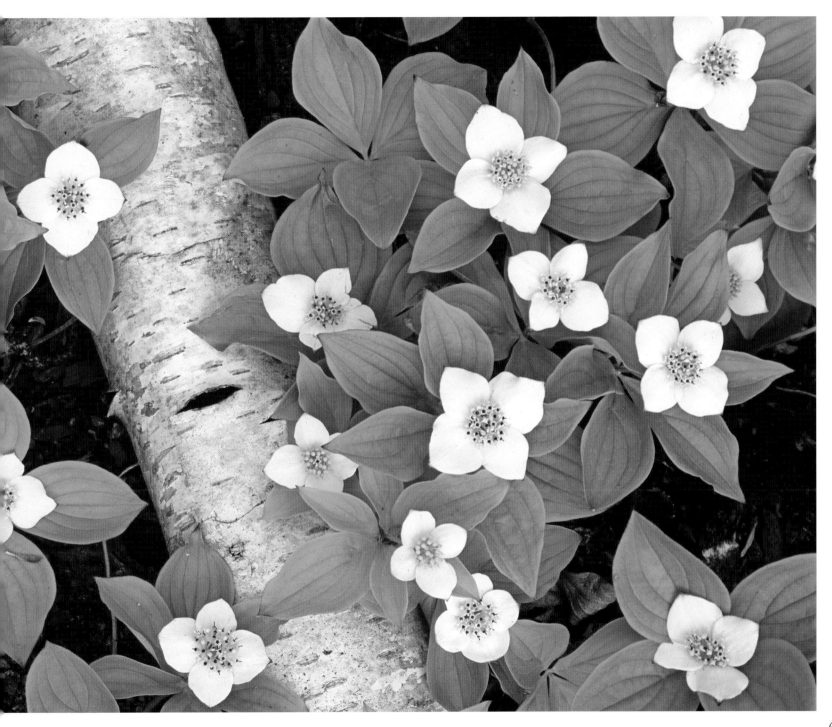

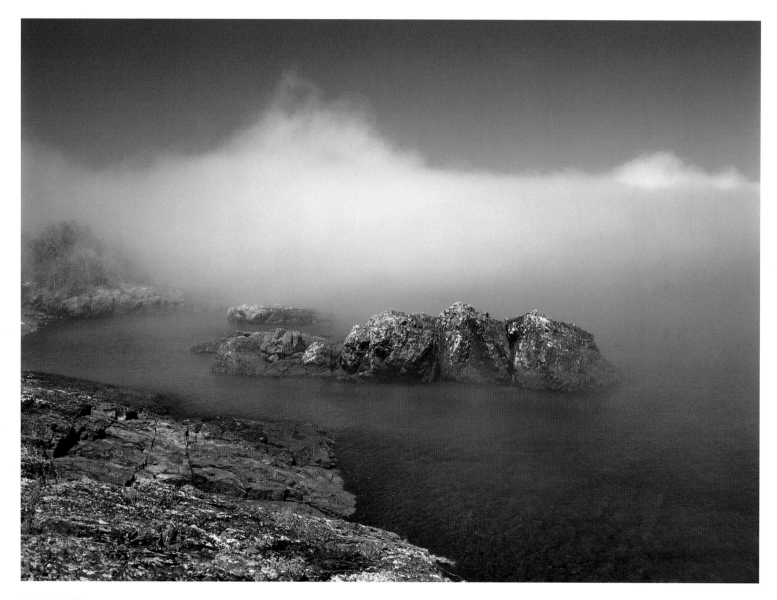

FOG BANK

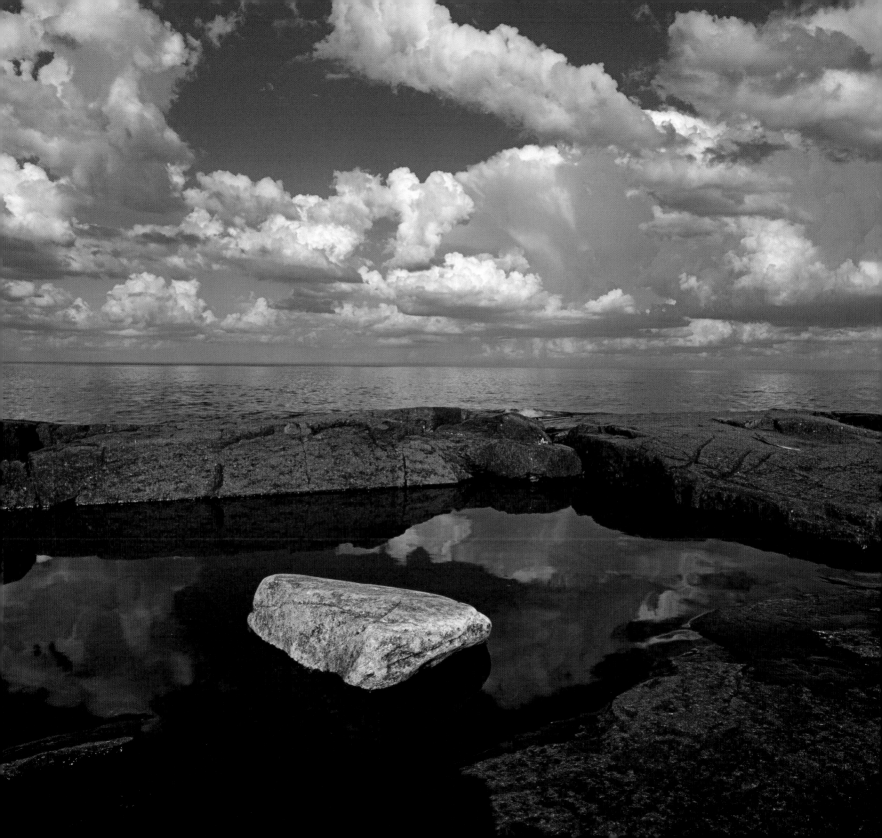

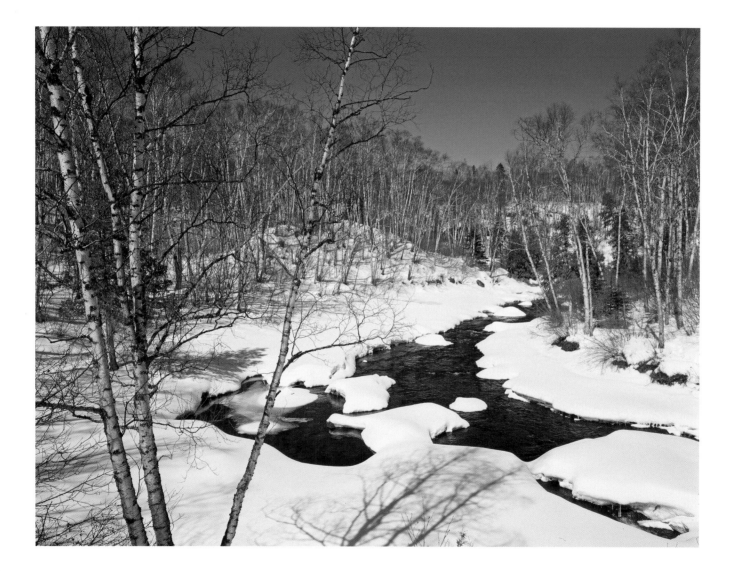

WINTRY BLANKET

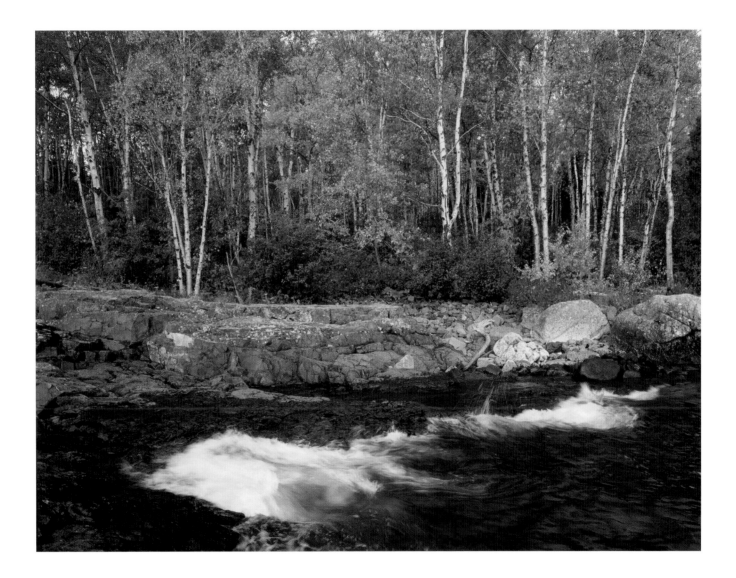

LAKESHORE COLOR

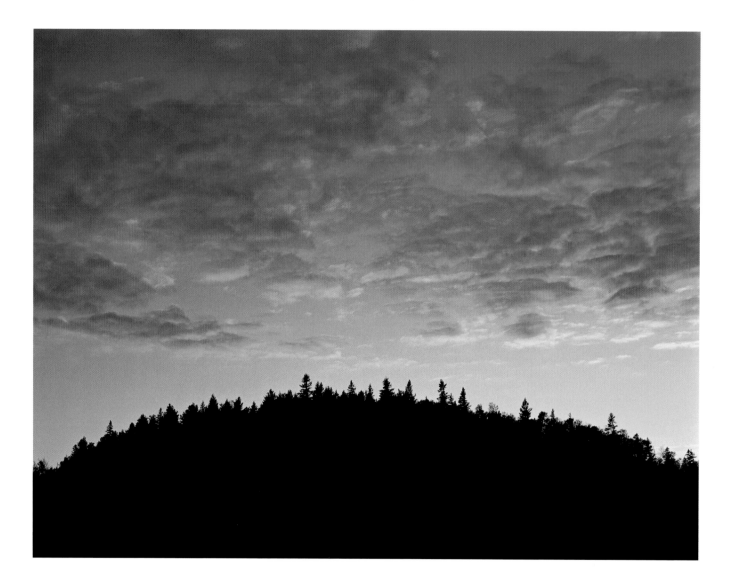

CARLTON PEAK

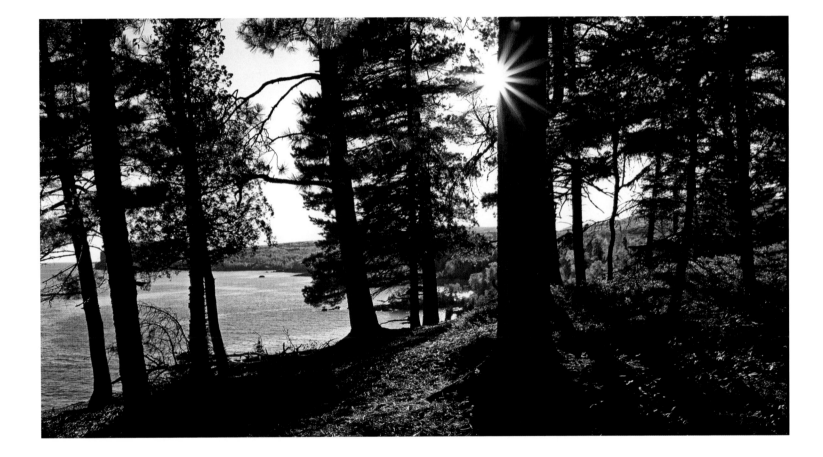

SUNBURST

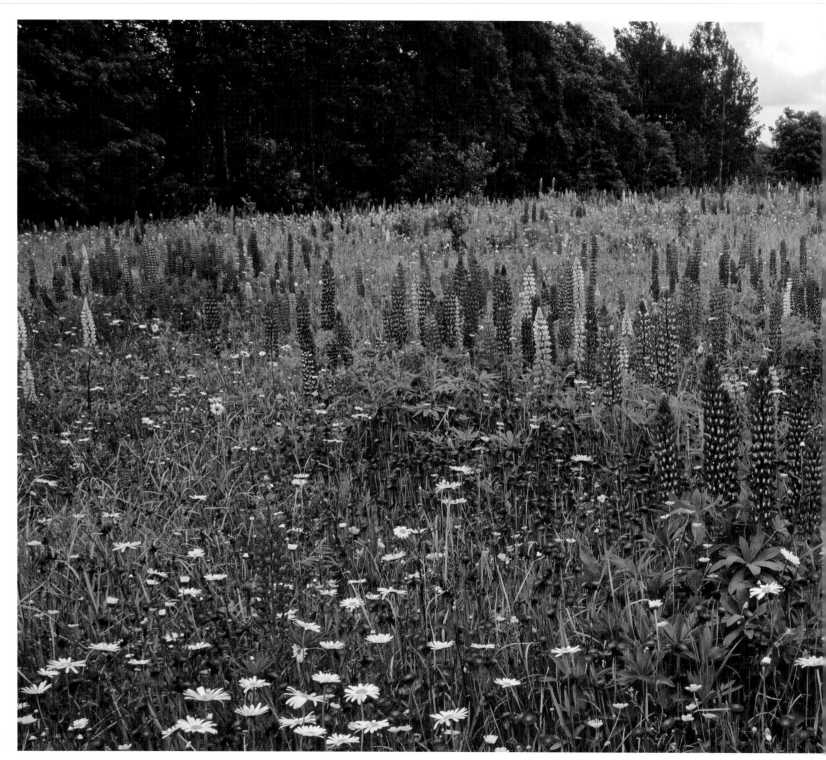

70

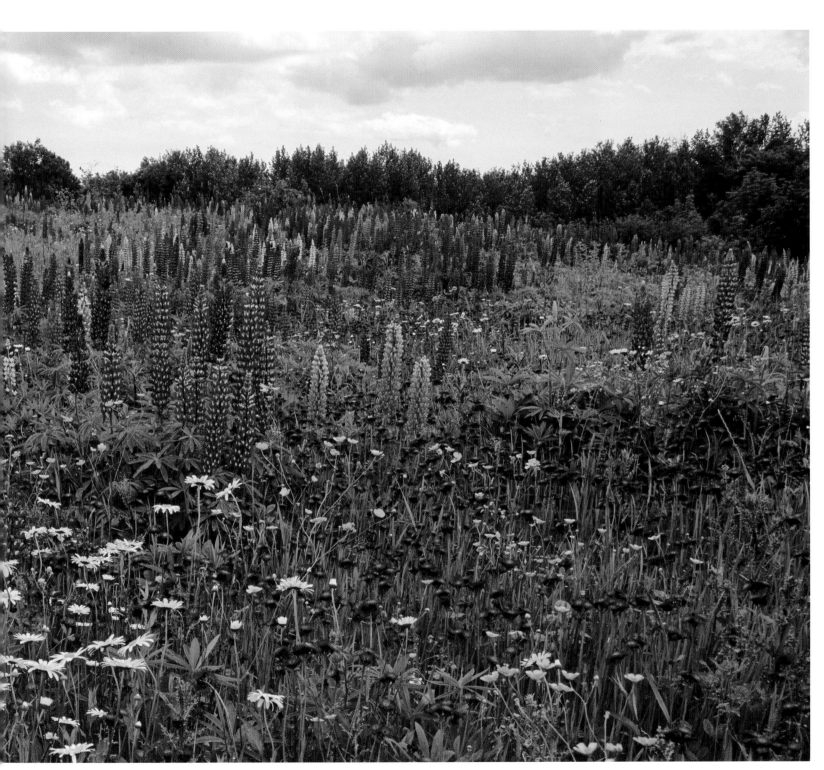

DAISIES

To Donna, who always found the flowers in life.

To order prints of the photographs in

**LAKE SUPERIOR
NORTH SHORE EXPERIENCE**

contact Jay Steinke Photography
1831 East Third Street
Duluth, Minnesota 55812
218-728-6046
email: jaysteinke@aol.com
www.jaysteinke.com

Book design: Jay Steinke

Cover design: Joy Dey, Jay Steinke

Printed in Republic of Korea: Doosan Printing

First Edition 5 4 3 2 1

ISBN 0-9635871-3-7

Published by: Tea Table Books, 1831 East Third Street, Duluth, Minnesota 55812

Distributed by: Adventure Publications, Cambridge, Minnesota 55008 ▪ 800-678-7006